SHOUTING IN THE DARK
My Journey Back to the Light

For Gloria:

Happy reading!

John Bramblitt with Lindsey Tate

I hope John's story inspires you!

Lindsey Tate!

Lyons Press
Guilford, Connecticut
An imprint of Globe Pequot Press

Lyons Press is an imprint of Globe Pequot Press.

Paintings by John Bramblitt

Text design: Sheryl Kober
Project editor: Kristen Mellitt
Layout artist: Maggie Peterson

Library of Congress Cataloging-in-Publication Data is available on file.

ISBN 978-0-7627-8007-5

Printed in China

10 9 8 7 6 5 4 3 2 1

To Jacqi for saying yes.

CONTENTS

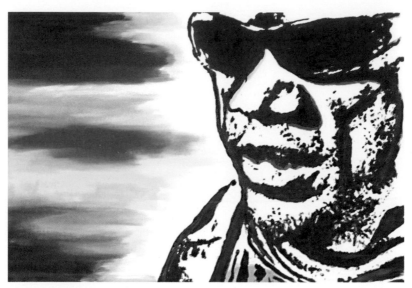

Henry Butler

INTRODUCTION

The sweet sound of New Orleans jazz surrounds me, intoxicating me. It's my favorite kind of jazz, all rhythm and feeling, and I'm being treated to a concert by New Orleans jazz master pianist Henry Butler. I've been invited here to do a live painting for the one-thousand-strong audience, to create a visual interpretation of the music on a huge canvas while Henry plays. I've never done anything quite like this before. I've painted portraits on live TV, and painted the sounds I hear in music and the tastes I sense in food, but I've never painted in a timed setting where my work has to be finished when the music stops. It's exciting to say the least.

I'm working fast, keeping up with the flow of notes, falling down on my knees to spread color at the bottom of the painting then lunging up to work at the top. I have horizontal ribbons of color blended across the left side of the painting, deep purples with hints of red turning into blue, orange, then a splash of yellow in the center. Before the concert I wasn't sure how the music would inspire me, so I mixed a whole range of paint colors and figured that if I listened intently and relaxed enough it would all work out. So far so good. Just a few minutes into the first piece the colors were obvious. They were right there in the music. Bold

colors. Living-life-to-the-full colors. As the music pulses through me, vibrant and joyful, the lively paints fill one whole side of the canvas. To the right I'm starting work on a portrait of Henry, but the audience doesn't know it yet. I've arranged the composition in my mind beforehand, figured out my brushstrokes so the seemingly abstract lines of paint will reveal a close-up of Henry's face just twenty minutes before the end of the concert. I want the audience to connect with the painting, to be able to recognize something in it. As a camera will be on Henry throughout his performance, streaming his face onto a huge screen for everyone to see, painting his portrait seems like a good idea. It's a lot to accomplish. And it's physical work. There's a huge expanse of canvas to cover.

Already we're one hour into the show. Henry has told a story or two between songs and a spoken word artist has performed, and I've kept on painting. Now there's a short intermission while Henry takes a break, and I feel my adrenaline suddenly kick in. We're halfway through the concert, but I'm not halfway through my painting. Nowhere near. I start picking up speed, working hard and fast, moving from the bowls of paint by my feet to the table that holds my brushes to the canvas and back again, changing colors again and again. My jeans and black shirt are splattered with paint.

In the back of my mind I'm aware that I'm perched up on an enormous stage, four feet tall, fifty feet wide, and fifteen feet deep, a stage just for me, with a camera trained on my every move. I'm the center of attention now that Henry has gone. I wonder if I look as agitated as I feel inside.

The music starts up again. There's a sense of relief that Henry's back and I'm no longer the sole focus, but it's as if the clock has started ticking again. I will myself to work even faster. I return my concentration solely to my painting and immediately everything

else takes a back seat. Henry's music, the presence of the audience, the thoughts in my head, all reduced in volume, scarcely background noise. All I hear now is the sound of my brush feverishly slapping paint onto canvas. Sometimes it just won't spread fast enough and so I'm spreading it by hand, pushing it into place, moving the portrait along. Sweat slides down my face. This much is normal for me, this intense concentration while painting that becomes physical exertion, but here I'm darting around all over the place. I feel like I'm running a marathon. I'm down on my knees dipping my brush again and again, racing against time. For a brief moment I imagine my wife, Jacqi, out there in the audience willing me to get it done, to get it right.

All too soon the music has finished and behind me I sense people in the crowd leaping to their feet applauding and shouting. I keep on working. All I can think of now are the colors and compositions in my mind, on the canvas in front of me. Someone is speaking over the loudspeaker. It's just words to me, distant noise. I register more applause and more speaking. I'm not listening. I'm lost in paint. Urging myself on. I'm lunging up to the top of the painting, applying black paint, concentrating, sweating. Now I'm adding purple, changing brushes, changing colors. Henry leaves the stage, there's more applause and I pour more paint. I will finish this painting if it's the last thing I do, if I'm here until midnight. My name is mentioned over the loudspeaker. I ignore it. There's more applause. Henry has been brought back to play an encore. I'm hoping he's chosen a really long piece and then, as if this is the way I'd planned it all along, I'm done. All of a sudden the painting is finished. With Henry's last notes I'm able to lay down my brush. The twenty-four-foot square canvas glistens with wet paint.

Between Henry's reappearance and me finishing my portrait, the crowd goes wild. I want to jump in the air or yell with happiness.

I'm relieved and exhilarated. I feel so grateful to be caught up by the audience in this swell of excitement. Behind me the painting shows Henry from his sunglasses to his shoulders, looking slightly to his right in the direction of the bright ribbons of color. Rough black lines make up his face while touches of rich color are mixed in here and there, matching the abstract colors that represent his music. White paint splashes across his face then beyond to merge with the streaks of color as if music itself is emanating from him. I've tried to represent his strength, his vitality, and his music all together, and it's funny because these very same emotions are surging toward me from the crowd as if we've all connected through the art and the music. It's a truly powerful feeling.

I make my way to the edge of the stage through the noise and goodwill of the crowd and sit down, my legs dangling into space, partly because I'm exhausted and partly because I'm not sure what I'm supposed to do now that the painting is done. People approach me, shake my paint-covered hands and say nice things about my art, about me, something about themselves. This is the part of my painting life that I love more than anything—that instant connection with others. It's real and immediate and it's why I started painting in the first place.

You see, ten years ago I went blind, the visual cortex of my brain damaged by constant epileptic seizures. I'm sitting on the edge of the stage with my guide dog, Echo, by my side. I can't see the people shaking my hand, nor could I see Henry playing the piano, or the portrait that I painted on the canvas. Not in any conventional sense of the word at least. When I lost my vision I lost my sense of self and my place in the world too, and it took a long time for me to find my way back. Before I went blind I had never picked up a paintbrush, but I became convinced that through art I could find myself again and reconnect with family and friends and, eventually, the world beyond. Luckily for me I

was right. And now I have the distinction of being able to say that I'm a non-visual visual artist.

I'm in Albuquerque this week painting music and portraits as part of the Southwest Disability Conference, a huge event taking place over several days that's designed to raise money and awareness for people with disabilities in all the states in this part of the United States. It's one of many such events that are held frequently around the country and which I attend as often as I can. I'm here as the Resident Artist of Texas at the request of the Texas Governor's Office. I donated a painting that was made into a poster, sales of which will raise money for educational scholarships for people with disabilities. As well as doing the live painting, I taught an art workshop to a crowded room of people in blindfolds, getting them to open their eyes to how people really perceive the world. It really makes them think.

So how exactly does a blind artist paint? If you think back to me standing on that huge stage with my paints, brushes, and canvas, I need to explain that I paint by touch. Basically, I see with my fingers. Once I worked out the composition of my painting of Henry in my mind's eye, I felt his face, section by section, and through my sense of touch my fingers were able to do the rest. Within moments of feeling his face I had an image in my mind, an image that I could call on when needed and so later I could paint his portrait. The fingertips are amazing sensors, and they give me so much detail that I then transfer through my paintbrush onto canvas. I should also add that I use raised lines to feel my way around a painting so I can tell exactly where I am and easily orient myself. I drew these lines before Henry started playing so they were there as a guide for me. They were white lines on a white canvas and not a visually appealing process for the audience, so I preferred to focus on painting color and getting to work on the portrait once the music started.

There's another piece to my puzzle that I couldn't do without: my guide dog, Echo. While I was painting, she waited patiently underneath the table, and when I finished, she walked with me to the edge of the stage and lay with her head in my lap. She's my trusty sidekick and constant companion. She stops me from doing things like tumbling off the edges of stages into the audience.

This train of thought leads me to remember an expression that people use without thinking: "The blind leading the blind." The second part of the expression states "If a blind man leads a blind man both will fall into a pit." It comes from the Bible and it's not very flattering about the blind, as it basically means incompetent people leading others who are similarly incompetent. There's even a painting about it from 1538 by Pieter Bruegel the Elder, which appeals to me as an artist, but the painting of six blind men all stumbling after each other into a ditch makes me think that life wasn't so great for the blind in the sixteenth century. I like to think we've come a long way since then. Did I mention that the jazz pianist Henry Butler is blind? I have to believe that in this case where a blind musician led a blind painter we produced something beautiful together with great competence and managed to stay far away from the edges of any pits.

The next day I sign hundreds of copies of posters for people. They stand in a line that snakes out of the room I'm in and around the convention hall. It's an amazing feeling, me sitting at a table, scribbling my name on a reproduction of a piece of my artwork for people to take back with them to their homes and pin up on a wall somewhere. It's still hard for me to believe even though I've done this kind of thing before. I talk to each person and thank him or her for coming, and they all say the nicest things about me. I could

sit there all day and soak up all the compliments because part of me doesn't quite believe they're for me, and part of me knows they're for me but doesn't quite understand why, and another part just says, keep them coming. These people are from all over the country and they bring with them something of themselves, their homes, their lives. A lot of them say I inspire them to share a part of themselves. They tell me about their troubles, or about a family member's disabilities, until I'm humbled by their trust in me as a listener. I'm their confidante. And I'm struck throughout the signing by how much people have gone through, are still going through, and by how hard it can be to come out the other side. I'm listening to stories of sickness and injury, of poverty, job loss, and death, but I'm not hearing people complain or bemoan their fate. Not at all. I feel lucky. I'm bearing witness to stories of hope and courage. People are laughing at the things they've experienced, talking about their past and their futures. And I'm hearing people say thank you to me for showing others that it's possible to want the impossible, to dream big and aim high despite the limitations of disability. Or because of those limitations. And I'm incredibly grateful to them for saying so. It's true. I was able to come to terms with being a blind man, but I didn't accept the limitations that were supposed to come with it.

Long after the last poster has been signed and the afternoon has moved toward evening, I'm still thinking about their words. This is the connection I was looking for when I decided ten long years ago that I could learn to paint despite being blind. When I was trying to find a way from my world back into the world I once knew so well but had lost on so many levels. Connection. It's something I constantly seek out through my painting. On days like today I feel that I have genuinely succeeded and it makes me feel good. So why is there an unsettled feeling in my stomach that I associate with guilt?

I think it's because the people I met today and yesterday at the concert and workshop, the people I meet at art workshops and lectures and art exhibits around the country and especially across my home state of Texas see me as I am today. An accomplished painter giving back to people with disabilities. A man who lost his sight and became an artist. They see me as an inspiration and I'm happy for that. But I don't want to be put on a pedestal. I wasn't always this way. I didn't leap into this new role perfectly formed. Instead I spent many dark, angry months unhappy with whom I had become, miserable with my lot in life, and certainly not an inspiration to anyone, including myself. When I became blind I thought my life was over. I was already struggling enough with epilepsy so what hope could I find for a blind epileptic? I saw myself as a burden, as someone whose body had failed him on too many occasions and left him without dreams of a future. Everything was dark.

When I think of myself standing on stage in front of one thousand people painting the sounds of jazz in vibrant oils, I'm amazed and delighted by how far I've come. My first paintings were undertaken in secret in my den and created in a steaming fervor of anger. There was nothing hopeful about them. In some ways I intended them as a slap in the face of fate. I hid them when guests came over so they wouldn't be embarrassed by more failure in my life, and when my mother found out that I was painting she didn't want to see my work. Just the thought of having to tell me truthfully that it was terrible, the prospect of seeing disappointment on my face again was too much for her to bear.

My journey from there to here is the story of who I am today. We all want to end up in a good place, but the old cliché is true— it's the way we get there that's most important. Now I see that it was okay for me to feel anger and disconnection because it fueled

me and drove me to find another way of being, another way forward. Because ultimately I had to understand that I was never going to get my old life back. Instead I had to make something new for myself. I had a long journey to undertake and none of my old maps or my old ways of being worked any more. It became a journey of reinventing everything I'd ever known, a walk in the dark in all senses of the word.

Hershey

Childhood: Medicine without Answers

When people ask me about my childhood, I always say it was happy. That's how I think of it: a happy, normal, all-American childhood. I lived with my parents in the suburbs of Dallas, Texas, and went to a local school. We moved a couple of times but not enough to make life seem unstable. We had houses with yards and a succession of dogs. Relatives lived nearby and cousins stayed over. I remember weekends of camping by a lake. It was the kind of childhood that, when I look back, gives me a warm feeling in my gut.

But when I start to really think about it, my childhood was far from normal and, at many times, was far from happy. When I was four years old, I started to get sick every three months or so. I'd come down with a virus and then another one. Or I'd have migraine headaches, pain down my left leg, or projectile vomiting. Even though these are classic symptoms of kidney problems, my pediatrician just couldn't figure it out. He'd try to treat one or another symptom but never looked at the big picture. Then he decided I just wanted attention, that I loved going to the doctor's office and having my parents worry about me. His medical advice: send me to my room every time I felt sick. Apparently I

was inducing projectile vomiting to get attention. My poor confused mother didn't know what to do, and I was getting sicker while she trusted the doctor's advice.

In reality I had congenital kidney disease, and my body was filling up with toxins because my kidneys couldn't filter them. As my kidneys grew, my symptoms, too, grew worse. This continued for three years. Instead of coming down with a virus every three months, I'd be feeling sick every other day and we'd be back at the doctor's office three times a week. Once my mom spoke with another mom in the waiting room and described what I was going through. Immediately this woman said it sounded like kidney disease. A neighbor's child had the exact symptoms and the pediatrician had diagnosed it as kidney disease. While the woman was happy to volunteer this information, she begged my mother not to mention her name if she talked with the doctor. He didn't deal kindly with people questioning his diagnoses.

So during my visit my mom asked if I might possibly have some kind of kidney-related sickness, and, of course, mentioned no names. The doctor became furious and said it was out of the question. And so the misdiagnosis continued.

Eventually I ended up in the hospital. My doctor sent me there thinking I might have appendicitis, but instead I was hooked up to an IV for an intravenous pyelogram (IVP) to test the function of my urinary tract and my kidneys. To the doctors there my symptoms were completely obvious. They injected an iodine-based dye into a vein in my arm and then took X-rays as the dye traveled through my bloodstream to collect in my urinary tract and kidneys. The contrast color of the dye turned these areas bright white on the X-ray images. From this test it was immediately obvious that my left kidney was not functioning, and that this was causing all the health problems I'd been having. The doctors were stunned

that I had gone undiagnosed and untreated for three years. My symptoms were absolutely textbook.

Finally we knew what was wrong with me. My kidney would be removed, and then we could move forward and leave my health problems behind. It was a relief for everyone, but especially my parents. While I had grown to accept my visits to the doctors and my days off school as normal—after all it had been going on like this for almost half my life—my parents knew otherwise. They had lived with the uncertainty and exhaustion of having a chronically ill child. Now they had a diagnosis. And while nobody wants their child to be diagnosed with a disease or to have to undergo major surgery, in many ways this was a positive thing for my parents. Now they knew what they were dealing with and could look forward to me leading a completely normal and healthy life with one functioning kidney. Little did we know that we were not out of the woods yet. Far from it.

The surgery went fine. After it was over I lay in my room in the dark listening to the movie *Orca,* imagining the scenes of the distressed, vengeful whale. I did that a lot back then, taping movies and listening to them without video. For a day or two all was good, but then I spiked a very high fever for no apparent reason. Doctors bustled around me and worried about infection, about having left a sponge or something behind inside me. We were back to medicine without answers. A couple of days before my surgery, the preacher at our church told my mom about a dream he'd had in which doctors were standing over me, shaking their hands, saying they didn't know if I'd make it through or not. Why he told her this I don't know. It wasn't very helpful and just made her refuse to speak to him for a very long time. When I was sick again with a raging fever, the only thing my mom could think about was the preacher's dream.

Eventually the fever went away and everything was fine—except for my doctor coming in to visit and grabbing me by my sides to say hello. I almost passed out with the pain. He was not my favorite person.

For six weeks I was symptom-free. No headaches, no viruses, no leg pain. And no visits to the doctor. I had a checkup at the hospital to make sure that everything had healed and that my right kidney was functioning normally. I just had to have the IVP test again. It was the same procedure with the needle in my arm except this time when the IV flow started I screamed with pain. It felt as if flames were eating the insides of my veins. The nurse said it was supposed to be uncomfortable but I knew it shouldn't be like this. I started thrashing in the bed, sweating, and screaming. I could tell the nurse was annoyed with me, but I couldn't help it. I didn't care. The pain was in my chest now, impossibly heavy, then heavier still as if all the weight in the world was pressing in on it. Suddenly the doctors were back in the room saying something about blood pressure. Everyone was talking and moving at once and then it all faded away, the pain, the noise, everything. I was floating above my bed and I saw a cart being rushed in with a machine with some kind of blocks and a telephone cord. A doctor put the blocks on my chest. At that point I grew bored and floated away to the room next to mine where I saw a blond girl in a blue and white hospital gown having a needle put into her arm.

I'd never seen her before. She was pretty, maybe a year or two older than I was, and I lingered for a while, light-headed, watching her.

Outside in the waiting room my mom listened to a couple of nurses gossiping about me, about my pediatrician and his misdiagnoses. She breathed a sigh of relief, glad that the guesswork and uncertainty lay in the past now, sure that a new healthy chapter in our lives was about to begin. Seconds later the nurses stopped

their chatter and rushed from the room. A Code Blue had been issued and everyone was scrambling. This was the first time that my heart had stopped. A doctor ran a crash cart into my room and used the defibrillator to get my heart going again. It would not be the last time. I was seven years old and had lost a kidney. I was also severely allergic to iodine.

My parents and I had thought we'd made it through. That it was okay to think about a future free of doctors and hospitals and waiting rooms. Now we weren't so sure. We'd been catapulted back into a world of confusion and questions where good health was tenuous. Little did we know that the nightmares were just beginning.

Colors

A Double Life

I was looking into the refrigerator for something to eat when my whole body started shaking. A strange tingling sensation shot through me from my head to my hands to my feet and I thought I was being electrocuted. I clung onto the fridge door while vaguely aware that I should let go if the electricity was coming from there, but then I couldn't think about anything as the tingling and the shaking turned into something bigger, something I couldn't control that took all my thoughts away. Everything became movement and pain.

The next thing I remembered was my mom's face looming over me. I was lying on the kitchen floor, the fridge door swinging open above me. My head ached. "John, what happened? Are you okay?" My mom's voice was gentle, concerned, but it seemed to reach me through a fog. I tried to stretch out and hold her so she could take away the scared feeling in my stomach, but I was too tired. I just wanted to go to sleep and not think about anything ever again.

That was my first big seizure. Looking back it became clear that there had been smaller incidents, moments of drifting away from the here and now, headaches and dizziness, but this was the

seizure that confirmed to the doctors that I had epilepsy. They gave me medicines, and I followed their directions and went about my life. Once in a while a seizure would take me by surprise as it had done in the kitchen and then I would spend a day or two at home, resting, but mostly I didn't let epilepsy bother me.

After each episode I bounced back into life as soon as I could, eager to see my friends and play sports, making up for the time I'd missed. I'd start practicing my karate moves in my bedroom again, spending hours perfecting them. I'd taken up karate the year before and loved the peaceful focus that came with it, the orderly progression through the thirteen different levels, based on skill level. I wanted to be a black belt.

Whenever I had a spare moment I drew pictures. Even when I was home sick and my migraines hurt too much to practice karate, I was able to lie in bed drawing. It was my way of working things out. Some people talk and others write while still others let their thoughts roil around in their brain, but for me drawing was the way I made sense of the world. I didn't run and show my parents what I'd drawn each time. I wasn't really interested in the finished product. I sketched whatever was on my mind, always working on getting the details down. The more details, the better. I was very visual and could draw from memory: faces, machines, objects. The stack of paper in my bedroom grew higher and higher until I cleaned up or needed more space, and then I threw the drawings out. I didn't need them anymore. I needed blank paper instead so I could draw something else. Besides, all my favorite drawings were stored in my brain in all their intricate detail.

In high school a flurry of seizures caught me unawares. I hadn't experienced anything like it before—the intense muscle contractions, my body rigid for minutes, loss of consciousness, and disorientation. When I came around I was bewildered and

exhausted. I didn't know where I was. I didn't know who I was. My world came back to me in vague degrees.

These seizures came completely out of the blue and disappeared just as quickly. I'd be walking to school with my friends or hanging out at a coffee shop and before I knew it I was lying unconscious on the ground. I got a lot of scrapes, bumps, and bruises that way. My friends learned to deal with it and to get help if the seizure seemed especially bad—maybe I was convulsing and flailing more than usual, or maybe it lasted longer than they were used to. But for the most part, they were just something that my friends and I dealt with and moved on from.

With my parents it was different. We spent a lot of time with doctors and in hospitals learning about the mysteries of both epilepsy and the human brain. Whenever I had a seizure, my meds were changed to something stronger, trying to keep the epilepsy at bay. The doctors wondered if puberty was causing my changes in symptoms, or maybe it was my brain chemistry that had adapted to the meds I'd been taking for the past couple of years. That happened all the time apparently.

Very quickly we understood that the treatment of epilepsy is not an exact science. Instead it is a delicate game of hit and miss, or try-it-and-see medicine in which a doctor prescribes an antispasmodic drug and tracks the results. If they are favorable, then the patient stays on the medicine until the epilepsy changes or the brain chemistry adapts. If negative, then the doctor tries another medicine, or a combination of medicines, and tracks the results again. Added to that is the fact that the drugs themselves can affect the way the brain functions so that after a few weeks you're treating a different brain than the one you set out to treat. There are so many variables. It is a very frustrating area of medicine for doctors and patients alike.

My parents and I often felt like we were walking on thin ice, unsure of when the surface would give way and never sure of why. We just knew that one day it would, and we would have to scramble to fix it until the next time.

In this way my life moved forward on two separate tracks. I'd have weeks when seizures wouldn't bother me, and I'd throw myself into school life, sports, and social activities. We went to Cedar Creek Lake, outside Dallas, on the weekends, and there I rode my dirt bike with my friends, went water-skiing, hung out with my cousins, and sketched down by the water. Then I'd have days when a seizure came out of nowhere, and then another one, until I was seizing every day for a week and I'd be out of school and back in the hospital for blood tests and monitoring. There I would draw away my frustration and live my other life.

I had friends in the hospital. There was Terry, who seemed to be there whenever I was. He was my age, with chronic kidney disease but always smiling. And Sopat from Cambodia, who suffered from polio, his body frozen into a fetal position. Trish with severe diabetes. Ann with cerebral palsy. We hung out and played video games or drove the nurses crazy by playing Frisbee, ignoring the various tubes and bandages on our bodies. I had constant blood tests to check the toxicity of my meds. My parents came to visit, bringing books and drawing paper, laughing with Sopat's family, who brought him dinner every night, steaming hot in ornate metal bowls. There was a sense of community there among the kids, a bond with the parents. It was just another part of my life for me.

The seizures reminded me of the fragility of my body, knocking me to the floor, and throughout high school I followed doctors' orders exactly. I ate healthily, tried to get enough sleep, and didn't drink when my friends brought out alcohol. I figured I already had enough toxins in my body messing with my brain so why push it.

Despite my vigilance I started to get sicker. My joints ached, and I was constantly exhausted. My seizures became more frequent, no longer controlled by the meds I was taking. My stays in the hospital became longer, the tests ordered for me more complex. On any given day I might have blood drawn, a spinal tap, an EEG, a bone marrow biopsy. It was as if the doctors didn't know what they were looking for and had decided to run every known procedure on me, hoping that something would come up positive. I lived with a Hep-Lock catheter in my arm, so every time I needed an IV or something injected into me the doctors and nurses could put it through the Hep-Lock instead of sticking new needles into my veins.

After months of looking and dozens of tests and retests, it turned out that I had a bad case of Lyme disease. How I could have contracted it down in Texas was a mystery, but the treatment was clear: A long course of incredibly strong antibiotics would wipe the disease from my system. Unfortunately they also wreaked havoc with my epilepsy drugs; so while my fatigue and joint pain started to disappear, my seizures raged. I'd wake up in my hospital bed, slick with sweat, with a nurse saying "John, are you okay? What's my name?" Usually I couldn't remember for a minute or two, and when I did my words came out slowly as if they weren't a part of me. I'd lie in bed wondering who I was and where the person I'd been just a few weeks earlier had gone. This seemed to go on for a long, long time.

But finally I returned to school and was well enough to hang out with my friends as if I'd never been away. I plugged back into my old life, happy to be sleeping in my own bed again, to have my parents around, and to see a stack of drawings on my desk. The two halves of my life were very different, but I accepted that. It was all I had known and I managed to both separate and integrate the two.

My high school friends were immature compared to the kids in the hospital. I'd learned from early on that age doesn't create maturity, experience does. My friends at the hospital knew that bad things happened in life, that people died, illnesses and treatments hurt. Kids are told that things will be fine, and when life doesn't work that way, they lose part of the essence of being a kid and maturity grows in its place. I didn't judge my high school friends for their immaturity. I reveled in it. In some ways it was just what I needed.

One night I was doing math homework when I got a call from Jimmy, a volunteer at the hospital. He was one of the funniest guys I'd ever met but his voice on the phone wasn't laughing. It sounded like the energy had been sucked out of it. He told me that my friend Terry had passed away the week before. I was shocked. Terry was smiling the last time I'd seen him. The dialysis hadn't worked, Jimmy said. They'd taken it as far as they could. His voice was flat, repeating phrases that he'd been told, stark sentences that covered a terrible truth. I didn't know what to say. I sat with the phone pressed against my ear, thinking of Terry. His big smile. He must have known that hope had run out for him, that he was going to die, but he didn't say anything. Hadn't said anything to me. He kept on smiling.

Jimmy told me that Terry had lived with his grandmother, that his mom was released from prison for the funeral and showed up in an orange jumpsuit and shackles. I hadn't known about any of this. My mind was reeling. I considered Terry one of my best friends. We had talked about everything together, but I hadn't known anything about him, about his family. I hadn't known he was dying. It was too much to take in. I felt like I'd really let him down. I listened to Jimmy's voice fade into silence then I hung up the phone and sank to the floor, my body racked with sobs.

Later that night when I tried to draw him I couldn't. I saw his face, his smile in my mind, but I couldn't put it down on paper. I didn't have the right. I hadn't cared enough about my friend to really know him, and now he was gone. I felt too guilty.

Self Portrait—Post Ictal

Epilepsy, the Monster Inside

Epilepsy had become the monkey on my back. No longer did it slip in once in a while, sidetrack me from my regular life for a day or two, and then leave. Now it seemed to be a constant presence pestering me with frequent seizures and toxic medicines, taunting me and threatening to take away my dreams. I had always wanted to go to college, even when I'd missed great chunks of school time and had taken classes at the hospital, riddled with tubes and in between seizures. I liked learning and had a million questions about the world, and I couldn't wait to get out there and find some answers. But now epilepsy seemed to lie in wait for me at every turn, skulking along the road to my future, ready to jump out and bring me to the ground. Literally. And lying on a concrete pavement somewhere, or regaining consciousness in a hospital bed, I'd have to admit that going away to college would have to wait. It was too much for me to handle at eighteen. I decided to enroll instead at Brookhaven, a local junior college, and when I was ready I would transfer my credits to a four-year university. While I accepted the reality of this plan, it didn't make me happy.

Maybe just the act of finishing school and knowing you're out in the big world makes you naturally grow up, but I began to think

about myself very differently, especially when it came to epilepsy. I had spent my high school years following doctors' orders, working with them to find the best medication to control my seizures, and it seemed to me now that very little had gone according to plan. My epilepsy was worse despite my best efforts. The seizures occurred more frequently and were more severe. Weeks of my life had been spent in a hospital. For what? Nothing had been fixed. I felt as if my life was on hold at a time when I should have been grabbing it by the horns, and it made me furious.

At Brookhaven I plunged myself into my courses and into college life and lived my life as I pleased. Tired of being viewed as a person with an illness, I didn't tell anyone—professors, administrators, friends—about my health history. This was the new me. And for a while it worked. My health was stable and I made straight As consistently. Then the seizures rolled in and I missed a few classes and watched my grades slip. When my health was good again, I'd pull up the grades until the next time I had to miss class. And so it went—a roller coaster of mixed grades and mixed attendance. The professors probably thought I was an unmotivated student as I never gave a reason for my absences. After a couple of semesters, I came to the conclusion that college would not work for me.

I felt such fury, such spite toward my epilepsy, as if it were a being outside of myself with a personal vendetta against me. I worked my swift revenge by drinking too much and staying out late, all the things the doctors had advised against. I no longer cared how I treated my body. If my health was going to sabotage me in this way then I wasn't going to look after it or care about it anymore. When I was tired or my head pounded with a headache, I continued with my plans anyway. I reasoned that by refusing to acknowledge my health issues they would get bored and stop bothering me. It wasn't reasoning fueled by logic.

My other response to dropping out of college was a need to control my own destiny in some way, to attack the bigger picture. For years doctors had let me down, sending my parents and me on a frustrated round of hospitals and diagnostic tests and now I wanted to take matters into my own hands. I enrolled in nursing school in nearby Dallas, determined to cure myself once and for all. With all my hospital stays and my dealings with doctors, I had drawn the conclusion that most medical work was done by nurses. While doctors might come along with their opinions and diagnoses, the real work with the patient was carried out by nurses. That was where I wanted to be.

Nursing school was an interesting mix of theory and practice, and I felt as if I related both to the patients and to the role of nurse. Importantly, I made the teachers and staff aware of my health history and they were happy to work with me and make accommodations. If I had a seizure and couldn't make it to class, they accepted it and I just made up the work. No one thought I was lazy or undermotivated. Everything was going well. I became good friends with a girl in the school called Danette, Net for short, and we hung out together after class and into the evenings. My personal knowledge of medicine came in handy, and I turned out to be one of the best students in my year. Then, with just one more class to go before graduating, the seizures started up again. It was as if they had an uncanny knack for making a grand entrance, for showing up when they knew they'd be least welcome and thus would get the most attention. I tried to ignore them but I couldn't. They were incredibly severe, several every day for several weeks, sending me back to the hospital, where I regressed into patient instead of nurse. I'd never known anything like these seizures. I felt as if I was in the grip of a hurricane, and I took to my bed to wait out the storms. When they finally passed, they left behind a very different person. Now I was emotionally and physically

drained. I was sick of my epilepsy, of my body that let me down at every turn, of hospitals, nurses, doctors. I was exhausted. No longer did I want to work in the field of health care. It was such a hopeless place for me.

I quit nursing school because I didn't have the heart for it anymore. I didn't ever want to be in a hospital again. I had lost the belief that my epilepsy could ever be stabilized, that it could ever be other than what it already was: a thief. It had stolen so many of my dreams. Twice it had stopped me from graduating. It was stealing my present and my future, taking over my life, and I was furious. Later I would learn that railing and fuming at an illness is a textbook reaction, but at that moment all I could feel was personal vengeance. Epilepsy was a monster, an enemy, and I fought against it in every way I could. If it wasn't going to let me do the things I wanted with my life, then I wasn't going to treat it carefully. I became purposefully reckless. Net and I went out drinking until late every night, and during the day I worked for eight to ten hours at my dad's business, Able Fuel Injection, a car repair service. I helped him on the computer side and when work was slow I drew intricate drawings of car engines for hours at a time, lost inside my brain. After work I met up with Net and headed off for another evening of drinking. The seizures were very bad, but I figured they'd been bad before, so drinking wasn't going to make them worse.

It became hard for me to keep up with my medicines, but it seemed that my body had grown up on them. They probably coursed through my veins, as familiar to them as the blood that ran through them. My life had become a list of antiseizure meds: Klonopin, Dilantin, Vicodin, Neurontin, Tegretol, Xanax, Diazepam, Phenobarbital, Valium, Clonazepam, and Valproic Acid. Every time my seizures got worse, the doctors upped the

dosage. These medicines were supposed to decrease abnormal excitement in my brain, and yet my brain felt overstimulated by the drugs. I experienced instant rage, a pure concentrated emotion that made me want to bang my head against a wall and scream at the world. A moment later the rage was gone, leaving me empty and disoriented. I laughed like a banshee then dissolved into tears, wished desperately for death but lacked the energy to act. Then out of nowhere I sensed the incomprehensible goodness of life and walked around with a smile on my face, happy in my own medicated world. I spent a lot of time in a mental fog. It seemed to reflect my inner feelings as I felt I had lost my way. I couldn't remember who I used to be or where I'd wanted to go. The only future I could imagine now was one where I would work at Able's by day and drink my nights away. It depressed the hell out of me. But more depressing was the fact that there was nothing I could do about it. My seizures had taken control of my life.

Net and I were perfect for each other, two wounded and broken human beings seeking shelter and company. From the moment I met her it was obvious that she preferred women to men, but it was hard for Net to admit even to herself that she was a lesbian. She had been raised in a very conservative family, and there was certainly no likelihood that her family would be supportive or even understand. She kept her true self a secret from them. It was really hard for her. We took refuge in each other's company. I saw our plights as somewhat similar, outsiders in the world, unsure of who we really were. I definitely didn't want to be an epileptic and Net wasn't sure if she wanted to be a lesbian. But these were our true selves, and until we embraced them it was hard for us to live properly.

There may have been a certain amount of irony in the fact that I became so close to Net. Or it could have just been pure need. By

now she was a licensed nurse and was therefore very useful for me to have around. If you're going to go out drinking while on a crazily strong concoction of prescribed seizure meds, who better to have as your drinking companion than a nurse? Maybe a doctor, but I didn't like doctors. We were a perfect team. It wasn't surprising to Net if in the middle of a sentence I started seizing and fell to the floor. It could happen in the blink of an eye like a switch being turned on. If it was a particularly intense tonic-clonic seizure, during which my body went rigid, then she would know to move hard or sharp objects out of my way. After the incident we would continue with whatever we'd been doing, despite the fog in my head, the pains, and the blurred vision. Often I wouldn't remember where I was, but as long as Net was with me I knew I would be fine.

In Net I felt as if I had found a best friend and an ally, and in a world that was hard to fathom it made sense for us to marry. We wrote our own vows, and within this minimal code of conduct we lived our lives. We had separate bedrooms and Net was free to explore her sexuality safe under the shelter of a typical relationship. And I had a live-in nurse.

Despite my desperate need to ignore my health problems, it was hard for me not to notice that my seizures were continuing to get worse. While in the past I may have had a couple of seizure-free months and then a period of seizing, now the time between seizures was less and less until it seemed like I was seizing all the time. The seizures themselves were lasting longer and longer, thirty minutes or more. I knew from my reading—and from myriad doctors—that just one seizure that lasted that long could cause brain damage. Or even death. And I was having several each day for a week. Throughout high school my biggest fear had been to live a life that was less than it could have been because

of my illnesses. Less respect, less happiness, fewer options. Now I was beginning to think that this was where my life was heading. Having grown up around illness, and the reality that illnesses could lead to death, I wasn't afraid of dying. At this point I would have welcomed that final seizure.

Piano Has Been Drinking

CHAPTER FOUR
Finding My Place

I had a headache worse than anything I'd ever felt pounding in my temples. It seemed to emanate from my brain and shake the walls and floor of the room so much the pain felt as though it was outside and in, and getting worse. I could feel my brain swelling. It was too big for my skull and I pictured it squeezing up against the bone, pressure building, pain excruciating. Rational thoughts disappeared, taken over by the discomfort, and I had a strange sense of being somewhere else, somewhere from a different time in my life. There were people from my childhood in the room with me. They were talking but I couldn't make out what they were saying. Then a surge of pain swept in and they disappeared, replaced by my old dog Sam. Or the sounds of a city street. Or the smell of burning popcorn. My brain ground against my skull, sweating, and making me cry out. Then there was blackness.

I drifted through the dark, my thoughts crystal clear. Looking down I saw my body and knew that I was dead, and I rose upward at great speed, the Earth a tiny speck beneath me. But even so I could see millions of tiny lights cast by the living down there. My initial feelings of detachment turned to joy. Looking up I saw a far-off light surrounded by smaller lights of all colors that made me feel elevated and clean. The light became

closer and I thought its intensity would reduce me to flames, but I felt only a warm glow. I realized I was looking at a form, and I felt sudden affection and spoke at length with this being. All my worries were gone.

The next moment I was alone, moving quickly through total darkness. Looking up I became aware of Net's blurry face close to mine, her hands pushing on my chest, the pain in my back as she forced it to the ground. I took a deep breath. Net was crying, her face red and sweaty. There was a banging at the door and suddenly two men were beside me and loading me onto a stretcher.

Net was with me still, talking, and I tried to listen to what she was saying about walking in and finding me with no pulse, about blood pooling in my back, but it was too much to take in and I waved my hands for her to stop. Through my blurred vision I glimpsed concern on her face.

"I had a wonderful dream," I said, my voice cracked.

"What about?"

"Nothing," I said. Sleep swept over me, heavy and dark, and I welcomed it.

Net administered CPR to me on more than one occasion and got me to the Emergency Room many other times. I knew that our marriage of convenience was as beneficial to me as it was to her. Now that she was a family member she joined me in these late night visits to the hospital, and I didn't have to worry about upsetting my parents again. I was well aware that if I died Net would be able to handle a visit to a mortuary much better than my parents. And given my fragile state of health at that moment, it seemed as if death could happen any day.

Net and I loved each other and wanted what was best for each other. We just didn't share a bedroom. With my health as precarious as it was, I wasn't looking for a girlfriend. There didn't seem much point in embarking on a relationship when I might not be

around much longer. Instead I accompanied Net to local gay bars and hung out with lesbians. I felt safe there and welcomed, as if my health set me apart from the mainstream world, and I was accepted as one of life's outsiders. We especially loved the bar Mable Peabody's Beauty Parlor and Chainsaw Repair. It was a bit of a dive but I liked its mirror-paneled wall and well-worn chairs, the fact that it didn't have a stage, just a patch of bare floor for the bands it booked to perform. And I liked it because I was accepted there. Kelly, the owner, went out of her way to make sure that everyone felt comfortable. More than a gay bar, it was a place for people to go who felt they were on the fringe of society. It was a place for being yourself.

My brushes with death had a two-pronged effect on me. First, they made me say, what the hell, it doesn't matter what I do, I'm going to die soon anyway. And that would have me working hard and partying hard again. But they also made me sit up and think that time was running out. If I wanted to achieve anything, then I needed to do it soon because I might not be granted the luxury of eighty or so years of life in which to reach my goals. My work at Able's was fun and to a certain extent challenging. And I had plenty of downtime for drawing. But it wasn't really what I wanted to do. My future plans had included being a teacher, maybe doing some creative writing. I started thinking seriously about college again.

For no discernible reason my seizures began to calm down. I hadn't changed my drugs or my lifestyle in any way. I had been accepted at the University of North Texas (UNT) and was happy to take this sudden shift toward the positive as a sign that my life was back on track. I wasn't naïve, however. I knew the mysterious nature of my epilepsy and was aware that a calm spell now could mean intensive seizure activity brewing in the future.

My first stop at UNT was the Office of Disabilities Accommodations. I had grown up a lot since my time at Brookhaven

College, when I had tried to reinvent myself and pretend I didn't have health issues. Now I knew that I needed to accept my epilepsy and tell the administrators about it so that when I missed classes—which inevitably I would—the professors would understand why and help me make up lost work.

It was incredibly hard to say the words, "I'm an epileptic." It felt like admitting a weakness, like failing and letting the disease win after all those years of refusing to let it do so. I was embarrassed and ashamed. I was disabled. Even as I pondered this, a thought popped into my mind: "only sometimes." And I realized that this was one of the problems with epilepsy. It was a sometimes condition, one that attacked and retreated, and made life confusing, unpredictable, and inconstant. It was impossible to know who you were if the boundaries were constantly shifting. I was well until I was sick. I was normal until I wasn't. It was exhausting but, for now, I was grabbing epilepsy by the horns, admitting to its presence in my life, and then hoping desperately that it would stay away.

And for a while it did. I settled into a new existence as a student, Net and I, and my dog Ann, living in Denton, embracing the thrill of a more settled life. We were together but separate, still each other's support system, but beginning to feel comfortable in our own small spheres. We had edged each other forward into the world.

The first class I took made me happy with life. It was English Literature and was so far away from everything I'd studied in high school and junior college. No rules of grammar and punctuation. This was like a course in philosophy, reading the thoughts of the greatest literary minds throughout history and discussing them. I was inspired. I took Art History, reveling in the study of my favorite subject, pondering the nature of light in the Impressionists.

Who wouldn't love looking at paintings and finding out about the place of art in society? I couldn't get enough of it. College was turning out to be everything I had hoped.

Seizures came and went. I missed classes here and there, irritated by their reappearance in my life, by the inconvenience of it. I hated having to find the professors, explaining what had happened and making up the work. It felt like I was making excuses, that I wasn't interested. Sometimes it took days to make up the work, because my vision would be blurred after a seizure and so it was hard for me to see. I did what I could while waiting for my vision to return, but at times I felt like I was constantly playing catch-up, especially when the seizures started coming one after the other. I'd experienced this before and knew it was just a matter of waiting out the storm and getting through it, but I was impatient to return to my studies, to my life, and I railed at my illness again. I was determined not to let it get in my way.

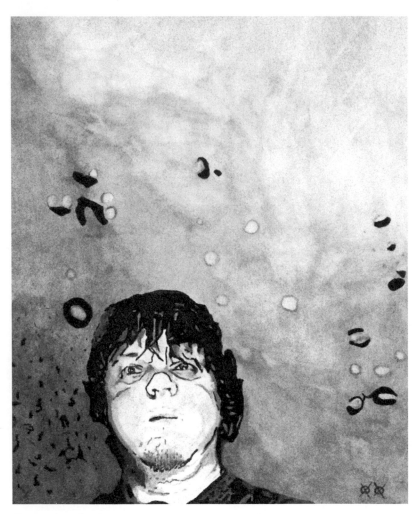

Drowning Again

Losing Sight

Late for class one morning, I waited impatiently to cross the street, fidgeting on the sidewalk as cars raced by. Finally all was clear and I started to cross. As I stepped off the curb, I heard a shout of alarm from my right, which made me slow down and turn. Then I became aware of a tremendous noise and sense of weight and movement in front of me, a blast of hot air, the screech of car brakes. A car had passed within inches of me, clipping the buttons on my coat and speeding away, leaving me to catch my breath. I stood in shock, heart pounding, unable to move forward or backward until someone came up to me and led me to sit on a bench. I followed like a child, still stunned. It wasn't so much the fact that I'd almost been run over by a car that bothered me, although that was shock enough. It was that I hadn't seen the car. As far as I was concerned, the street was empty and safe to cross.

"Didn't you look?" asked the person who'd helped me to the bench. "You just stepped out. I didn't think you'd seen it. That's why I called out like that."

She had probably saved my life, this elderly woman on a bench. I didn't answer. I had looked before I crossed the street. The problem wasn't my looking. It was my seeing.

I decided to miss class that day, which wasn't something I did lightly. I already had enough days when I was having seizures or recovering from them when I couldn't attend class, enough courses that were Incompletes, so I didn't have the luxury of not showing up on a whim like some of my friends. But now, sitting on the bench, with the smell of singed rubber still in the air, I became aware that my vision was blurred around the edges. As if I were living in a soft-focus movie. Or a dream. I decided to see an eye doctor. Probably my contact lens prescription needed changing. Seizures always left me with blurry vision so it wasn't anything new, but sometimes it was good to check things out.

Later that morning while waiting in the doctor's office, I realized it had been a while since my last vision test. In fact, I couldn't remember having had one since starting college without my mom to remind me or schedule one. But the eye charts with their letters and the trays of different lenses all seemed familiar enough for me to breathe and relax. The ophthalmologist skipped the small talk and started in on checking out my sight. He slipped different lenses in front of my eyes, adjusted the sides in a professional manner, and asked me to read the top line of his charts. When I couldn't he switched lenses, asking, "Is this better?" It wasn't. He tried several more times, his brow furrowed and pained. Finally he pushed back his chair and sat, arms crossed, away from me. In exasperation, he blurted out, "I deal in vision not the lack of it." I stared at him. He didn't explain, just continued, "You need to go to the Division of Blind Services." With this pronouncement made, he left the room. He may as well have said a spell to turn me to stone. I sat in the leather chair, rigid, trying to process what he had told me, but mostly I was just outraged by his rudeness. How could someone dismiss me like that? Treat a fellow human

with such lack of courtesy. And say such a strange thing. I felt misused and miserable, and eventually made my way home.

The encounter nagged at me all day, bubbling under the surface of my daily schedule. I was still smarting at the eye doctor's brusque attitude, but there was some concern too about my eyesight. My vision was blurry, that much was true, and it had been for some weeks now. But that often happened after seizures. That was one of the things with epilepsy. The seizures took you to someplace else and when you returned your sight or sense of taste or time might lag behind a little. But it always came back.

Except this time it was taking longer than usual. I decided to follow the eye doctor's advice and have my eyes checked at the Division of Blind Services. Probably they knew about epileptics with blurred vision and could give me some tips on handling vision loss until my sight returned. And I was sure they wouldn't be rude about it.

My appointment with Dr. Fleming was in the Low Vision department, and as I sat in the waiting room, I worried. I was reminded of all those doctors' waiting rooms I had sat in since my early childhood. There was that familiar sense of dread, of waiting for a sentence to come down. The knowledge that you may go into the doctor's office as one person and leave as a different person, with your entire world turned upside down. I had seen that so much in my life with people I'd met in hospitals or seen in waiting rooms or in the ER. Just one visit could rip your life apart.

As I waited I listened to the voices and laughter of children at a nearby daycare center, catching glimpses of color as they flashed by on their way to and from school. Through my blurred vision I noticed a woman sitting, very straight backed, in a cubicle. Leaning against the wall beside her was a long white cane, its reflective surface catching the light and drawing my squinting

eyes toward it. The woman sat very still and composed, reading a large, white book without print of any kind. She stared straight ahead, her hands moving lightly like butterflies across a page. I'd seen people reading Braille before, but now, the more I looked at her, I wondered if she might be a special message to me. Some sort of premonition of my future self. I was struck by her calm as it seemed to be the exact opposite of the nerves roiling inside my knotted stomach. I blinked and reblinked as if trying to reset or jump-start my blurred vision. As if trying to change the channel. But each time my eyes opened, the woman was still there. In the end I closed my eyes, blotting out her image, took some deep breaths, and tried to focus my mind on the children's laughter. It didn't work as the mind's eye is a powerful thing, and there she was in my head with her book, her fluttering hands, and her cane. Finally I heard my name being called.

A nurse came toward me and held out her arm. I grasped at her hand. She took my hand and placed it gently but firmly on her arm, in the crook of her elbow. "You'll find it much easier if you hold on here. You'll be able to tell if I'm starting, stopping, or turning." Then we set off. She was right. I was surprised by how much difference one little piece of information could make. I had been having Net guide me around by holding my hand when I needed it.

The doctor's office had white walls and white floors and for me it all blurred together until I felt I had snow blindness. Through this wall of weather I met Dr. Stephanie Helm Fleming. She was a young doctor with a degree from the University of Houston, the top school for low vision medicine. Immediately striking was her gentle, cheerful manner. She started me off on tests, clicking lenses in and out, telling me about the different machines she was using and what the tests would tell her. She was strikingly

different from the other eye doctor. We could have been having a conversation over cappuccino at one of the university coffee shops if it hadn't been for the steady thrum of anxiety in the pit of my stomach.

The exam seemed to go on for a long time, an hour at least, and in many ways I was happy to prolong this portion of my day, listening to Dr. Fleming's cheery words, warding off the inevitable. But eventually the barrage of tests slowed and drew to an end. Dr. Fleming accompanied me to another office to go over the results with me.

I sat down in an examination chair, surrounded by a slew of unfamiliar objects connected with ways of seeing. Dr. Fleming pulled her chair up close to me. In a soft, even voice she said to me, "John, you're blind." They were the worst words anyone had ever said to me in my entire life. I felt as if I'd been punched in the stomach. And at the same time I was surprised that I was shocked. Deep down, I had sensed that the tests were not going well. Not that Dr. Fleming had changed in any way during the examination, but she had pulled out lenses of a higher and higher magnification, and she had done more and more tests. And before that I had known there was something wrong with my sight, something different from the blurred post-seizure vision I'd been used to. So I experienced a double-barreled reaction. I'm blind. But you knew that anyway. But blind? There's a very big difference between thinking something is a maybe and then being told it's an incontrovertible reality. A very big difference.

I could hear Dr. Fleming talking, telling me that there were many ways in which I could be helped, how we could start with adjusting to my new life right away. And I could hear myself answering that I would like to start in on that as if I was talking

about a new course to sign up for at school, and my voice was distant and polite and not me at all because the real me was falling headlong down a pit. A terrifyingly dark pit from where there was no return. From the bottom of this pit, I listened to Dr. Fleming's voice. She was saying that probably the severe seizures had caused my blindness, or maybe the epilepsy drugs. It didn't really matter. All I could wonder was how someone so gentle and kind could say something so terrible. It didn't seem right or even possible. Like a baby cursing. I replayed her voice in my head in the darkness of my pit, "John, you're blind," "John, you're blind," and even though I said it many times it didn't sound any better than the first time I'd heard it. I felt panic clawing at my insides.

I was brought back to reality by the stark mathematical figures of my blindness. Everything else that Dr. Fleming told me washed over and around me like tears, but the cold, hard numbers caught my attention. Perfect vision is 20/20. Legal blindness is 20/200. This meant that what other people could read at a distance of two hundred feet, a legally blind person could only see at a distance of twenty feet. On that day she had measured my vision to be 20/400. I heard this as my vision was twice as bad as a legally blind person's even though those were not the words that Dr. Fleming used. I was able to read at twenty feet (with contact lenses) what other people with perfect vision could read from one and one third football fields away. This thought made me mad. No wonder I'd had trouble crossing the street.

Dr. Fleming continued on in her sweet voice that left such destruction in its wake. "There's no way of knowing for sure, but given the past progression of your vision loss," she said, "it would be a good idea to start learning techniques with a cane. To prepare

for total vision loss." My whole body tensed up. I saw again the woman in the waiting room with her cane and her book of Braille. I had guessed right. She was an image of my future, seen through my miserable, blurry, twice legally blind eyes. I wanted to throw up. I suddenly wished that the car had hit me, then all of this would be over.

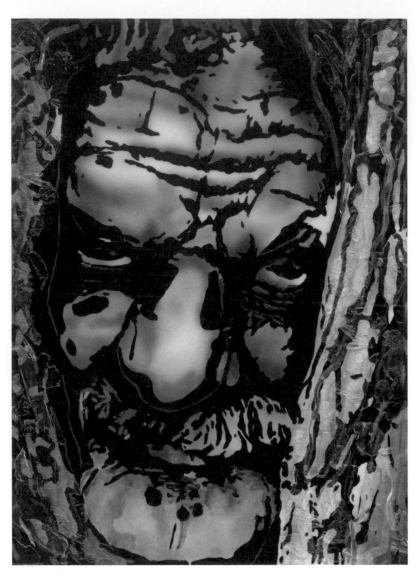

Iago

A Race against Time

Dr. Fleming had delivered the news to me in exactly the right way—concern and empathy mixed with upbeat, practical advice. I wouldn't have wanted her to tell me in any other way or to have heard it from any other doctor. But when it comes down to it, there's no way to take the words "complete vision loss" well. Just as I had predicted while sitting in the waiting room, one doctor's visit can completely change a life. I had gone in thinking I had some temporary vision issues and had come out as a blind man. It felt like a death sentence. The thing that Dr. Fleming had done, although she didn't know it and certainly didn't mean to, was to change who I was as a person. I realized now that I had been living in a kind of twilight world in all senses of the world. That had fundamentally changed. I had a new diagnosis and it left me without hope.

When I thought about the fact that I was blind, it still came as a shock to me. When I told Net she looked puzzled. "But how?" she said, as if something new had happened since she'd seen me that morning, as if I'd had an accident with my eyes on the way to my appointment. "I've been blind for a while," I said. "I just didn't know it." It didn't make any sense to me, to her, to all the other people who asked and then would gape at me. How could I be

blind? Or, more to the point, how could I not have known I was blind? And yet it made all the sense in the world.

Until I sat in the chair in Dr. Fleming's office I had never thought of myself as someone with vision problems. Yes, my vision was bad at times, blurry like looking through gauze, but I always thought of my problem as the seizures. When I didn't have seizures, my vision was fine; when I did have them, one of the side effects was blurred vision. This much I knew and had been used to for much of my life.

Thinking about it now, I realized that my seizures had been pretty bad over the last few weeks. That happened sometimes. They came and went in no particular order or pattern, sometimes going away for weeks at a time and then returning with a vengeance. I'd had a couple of huge status epilepticus seizures, which had made me miss school, but that was nothing unusual. These had been followed by a bout of dozens of smaller seizures. It had seemed that no sooner had one seizure finished and I'd come back to the world than another one had started up. I'd been left exhausted, washed up, and with blurry vision. And my vision didn't have a chance to clear up as usual between seizures. I hadn't thought this was strange because it made sense. Just as my vision would normally be coming back, I'd had another seizure and so my vision never recovered. It would return like always, I was sure of it. It was just a matter of time without seizures. My main focus was on getting myself back to class and making up the time and work that I had missed.

When the seizures stopped, my vision didn't return. Somewhere at the back of my mind it struck me as odd, but I figured it was taking a little longer since the seizures had been so strong and so numerous. I didn't really think about it, even though my eyesight was noticeably bad. I went from being able to recognize a friend from one hundred feet away to fifty feet,

then thirty, twenty, ten, and then I'd have to be right up next to him before I'd know for sure. And even then sometimes I'd have to hear his voice to really know. Even so I wasn't worried. I was sure that this was just a bad time with the seizures and that it too would pass.

Then more seizures started up before my vision had a chance to improve, another bout of big ones followed by a flickering of small ones. It was around this time, probably a week later, when I was almost sideswiped by the car. By then I had gone several days without seizing. Things were looking up, and I was hurrying to school to catch up on class again. Time was a precious commodity right then. I never knew how much time I had before the next seizure would strike. In some ways it was like living in a war zone—running out to get as many things done as possible before the next bombs fell.

Except in this case I'd been ambushed. The expected bombs did not fall, at least not right away. Instead I felt like I'd been held at gunpoint and had my life taken away.

"John, you're blind." I heard those words in my mind over and over again. Each time they presented themselves to me, I both pushed them away as if they didn't refer to me and pulled them toward me to take them in my hands and throttle them. I knew these words had opened a whole new chapter in my life, one that could only be viewed as a horror story, one that could only end badly. In fact, they were both the beginning and ending of the story. It was not a story of promise.

After Dr. Fleming's diagnosis I lived a double life in different ways. I lived an interior life full of emotions I didn't want to share or even know how to voice, and an exterior life in which I stumbled through the motions of living my former life. I lived a life where I hated being blind and refused to admit I was blind, and a parallel life where I kicked at the confines of blindness,

clawing and screaming, refusing to let it beat me, determined to conquer it.

The evening of my diagnosis my parents called. They had known I was going to the doctor, knew the whole story of the car and the rude ophthalmologist, and were calling me for an update. What could I do but tell them the truth? It would have been better in person, but I didn't have that luxury. My mom went silent and I knew she was crying. I imagined her at the other end of the phone trying to hide her sobs but unable to keep them inside. I pictured my dad coming down the hall, puzzled, comforting her, his face questioning. When his voice came on the line I could hear him shaking, could still hear my mother's smothered weeping. "John, is it true?" he asked. I said, "Yes," and he was quiet. I knew he was crying, too. The only time I had ever known him to cry was when his beloved brother-in-law died. Then we had sat together on a bench in the nursing home, dressed in suits, mine with a child's clip-on tie, and my dad had cried and shaken next to me. I thought of that moment now. My parents' emotions pained me in a deeply visceral way. They cemented in my mind how truly awful my situation was. It was as if I hadn't been sure how to react to the news but on hearing their reaction it confirmed my worst suspicions. I was right to be miserable. I didn't blame my parents for their reaction nor did I wish that they had laughed and told me to embrace my new way of life. Instead their tears showed me their unconditional love, and I knew at that moment I had their wholehearted support. I also knew that I never wanted to be a burden on them. I would do everything in my power to finish my degree, get a job, and live independently.

From that moment on my life became a race against time. There was no way of knowing how long my remaining sight would last. I had been told to expect the worst, and so I prepared for that impending day of total vision loss with the intensity of a

professional athlete. I felt as if my house was on fire, and I had to rush in and grab as many of my personal items as I could before the whole thing disappeared in a black spiral of smoke. Or as if the whole planet was being destroyed, and I'd been given an unspecified amount of time to gather items that I'd take to another planet, knowing I'd never return here again. I lived in a constant state of busy panic. Now I needed to keep blindness and epilepsy at bay.

My approaches were manyfold. First, I was desperate to continue with my life as it was, including school and social life. This presented challenges as it was hard for me to get around, and getting harder. I moved from an apartment on the outskirts of town to an old carriage house in the center of the university district. This put me right in the middle of things which, in theory at least, meant that I could walk to classes, coffee shops, and taverns. I found out right away though that getting around is one of the biggest problems for the blind. It's just plain scary to leave a house or apartment and launch yourself into the chaos of sighted human existence, which is probably why so many blind people choose to stay inside. I didn't have that luxury. My deadline of doom sent me out into that terrifying world time and time again, hunting and gathering as much information as I could before the permanent darkness fell.

My friends escorted me to classes and back, or out for a drink and back. Sometimes the Office of Disabilities arranged for people to assist me as well. I started using screen readers and magnifiers to help me read my textbooks and assignments. This all worked nicely, if slowly, on a practical level, but it wasn't really getting me ready for the future. I felt as if I was just treading water, barely keeping my nose above water level, and if I was feeling like this while I still had sight then drowning was a likely option for the future. It wasn't something I was willing to contemplate.

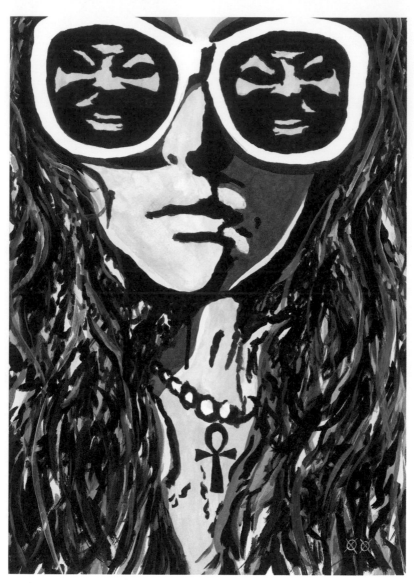

Sunglasses

Invisible

Help arrived for me in the person of Alexa, a trainer in Orientation and Mobility whose services were arranged through Dr. Fleming's office. She showed up at my apartment door, armed with a long white reflective cane. Even with my fading vision, I could see that cane and I hated it. If I could see it, then how conspicuous and ridiculous it must look to all sighted people. It would shout out the nature of my disability to everyone. I wasn't ready to go public. But I had to. I knew I couldn't be squeamish or sensitive. I needed to learn to get around on my own, and I needed to learn fast.

The first time I went out of the apartment with Alexa, I was thinking, "I hope no one I know sees me." With one hand I held her arm just above her elbow and with the other I held the cane. It stretched out in front of me, its whole five feet, and seemed to glow like a laser, attracting the attention, I was sure, of everyone for miles around. Just when I felt things couldn't get worse, Alexa handed me a blindfold. "It'll be easier when you wear it," she promised me, which didn't make any sense. It was a dark, black mask designed to blot out the sun. She explained that now, as I could still see, my brain would be focusing on what I was seeing with my eyes instead of what I could visualize through touch. It was important not to get confused by visual stimulus. "Even if

you have total vision loss, you may still have some light perception, so then you'll want to wear the mask or dark glasses for the same reasons."

So with my guide, my cane, and my blindfold, I set off slowly along the sidewalk, feeling humiliated and angry that it had come to this. It was amazing to me the level of concentration I needed just to walk forward. I was supposed to be feeling the vibration of the sidewalk through the tip of the cane and, through this sensation, to draw some conclusion about how it looked, where it ended. All I wanted to do was rip off the blindfold. Not that I could see much better without it, but at least I could still make out the blurred outlines of people, cars, and bicycles. There was light and a kind of muffled color. With the mask there was a bewildering uniformity of unrelenting black that seemed both to stretch to infinity and set up a barrier right in front of me, as if I were going to bump into a wall. My whole body leaned backwards away from the world, and my steps were slow and tentative like explorations on thin ice.

"Walk forward. Let the cane read the terrain for you. It will work out, I promise you." Alexa was upbeat and practical and I wanted to believe her. But already I was thinking, she's from the sighted world. What does she know?

Our first outing took us to the end of Hickory Street and past shops and restaurants. I sensed people around me and more than once felt the cane stutter and hop as if it had hit something, a café chair or a person. I imagined people falling down like dominoes, myself a little like Inspector Clouseau or, worse, Mr. Magoo. Luckily, I couldn't dwell on these images. The work was too hard, the focus on the cane, my hand, my feet, sounds all around. I learned to sweep the cane to the left as my right foot moved forward, then to the right as my left foot followed suit. My hand tensed over the cane. Alexa was trying to make me relax,

but try as I could, I clung on to the cane for dear life. I hated it but needed it.

Alexa told me there was another grip I would learn for navigating busy or crowded places, as it would give a lighter touch, which, in turn, would give me more control, more depth of feeling. She called it the pencil grip. "Take the cane," she said, "and imagine you're holding a pencil." I did, and immediately a bunch of emotions swept over me. I hadn't held a pen or pencil since my visit to Dr. Fleming. It was too depressing. I couldn't see anything I drew. But standing in the middle of the sidewalk suddenly feeling that familiar grip made me realize how much I missed holding a pencil. Whenever I had been sick before, or just unhappy or confused, I'd had my drawing to make sense of the world or to take me away from the world. It had been my own private pastime when I was a kid in the hospital. I had constructed fantasy worlds on paper, detailed maps of airplane engines, or crazy cartoon characters. They were my escape; my way of not thinking about reality. And I had continued with my art throughout high school and college, pulling out a sketch pad and losing myself in sketch after sketch. It was part of me and I hadn't really noticed it until now. Until it was gone. My best way of dealing with my blindness had been taken away by it.

This realization seared through me, leaving me raw and angry. It seemed that every part of my life now was about things I couldn't do anymore. Or couldn't do as well. The image of the burning building came back to me. I wasn't grabbing personal items anymore—everything I had owned before was now damaged in some way, was less than it once had been. I could salvage only a shadow of my former life. I now thought in terms of scaling a mountain. If my life before had been filled with simple hopes and dreams, and I had been aiming for general movement upward toward the summit, then I was now in a state of

plummeting, headlong, toward the rocks below. All I could do was throw out a hand and grab for a branch to stop my freefall, to keep the inevitable at bay for a little while. My only way to succeed was not to fail completely.

I think if my vision had already been gone when I first met Dr. Fleming, I would have given up. I would have gone straight home, curled up on my couch, put on some music, and settled into darkness. I would have seen my future as a hopeless case.

However, given my diagnosis of impending vision loss, I fluctuated between depression and action. I had a mission to complete. I trained with Alexa whenever I could. She was my link to a world where I could possibly survive alone. We met in the evening usually, as daylight really bothered my eyes now, turning them bloodred and painful. This was because my vision problem lay in my brain and not in my eyes, so they continued to function, dilating to let in light. Even blinking was painful. Infections set in as if the eyes were manifesting their own version of blindness—or my own mindset. I felt a sense of purpose with Alexa. I was happy to go outside. In my world of restrictions, where I was struggling to perform tasks I once had found easy, it was good to feel I was learning again. Even if it was relearning.

One Tuesday evening Alexa and I drove away from the university center in her car as usual. I sat in the passenger seat feeling the car lurch around corners, change lanes, and speed across intersections, trying all the time to figure out where in the metroplex we were. As if we were in a James Bond movie traveling to a secret location and I had been blindfolded.

"Where do you think we are?" Alexa asked. She had driven for about ten minutes. "By the Jupiter House," I said. "Very good," she said. "We're right next door at the Golden Triangle Mall." I could feel myself grinning from ear to ear. I was good at this. It could have been pure good luck, but I had definitely felt a sensation of

speed in the car as if we were going along a freeway, and then I had smelled coffee, intense dark coffee, which made me think Italian roast at a coffee shop. I added this information to my mental map.

"Malls are great for training," added Alexa. In my mind I pictured a wide expanse of concrete and columns. I'd been here often enough with Net. There was a Michaels Crafts that she liked and a Best Buy where I admired the latest computers but never got around to buying one. I imagined myself sweeping my cane back and forth across the shiny floors of the mall, ending up at the coffee shop near the exit. I felt confident. My cane work was getting better.

One of the things that Alexa had taught me was the art of trailing. Basically you find a wall and, using the back of your hand, you touch it lightly and it gives you a sense of direction, of following a straight line. When I first tried to walk in a straight line without using the trailing method, I was surprised by how hard it was. Sighted people rely on cues all around them to walk forward. Without sight it becomes remarkably more difficult. Hence, trailing.

"First, you're going to walk straight across, John," said Alexa. Already my feeling of confidence was eroding. The elegant open space of the mall that I had seen in my mind was not the same as the one I could sense around me. Here I heard the echo of people. Children shouting, babies crying, laughing packs of teenagers. Crowds. I started to sweat.

I stepped forward, sweeping my cane to left and right, keeping a comforting contact with the floor. I was searching for a wall to trail. My cane stretched across an endless open space, which made me nervous. Surely I was going to bump into someone or something. I kept on walking. Step, sweep, step, sweep. Eventually my cane found a wall.

"You're outside a store," said Alexa. She gave me hints now and then to help me visualize and store up information for the future, but for the most part she let me figure things out for myself.

I trailed the edge of a store, sensed electronic doors sliding open as I walked past and activated them, then I continued along into the mall. Suddenly the wall shifted to the left. My straight line had turned a 90 degree corner. Should I follow it and head into another part of the mall or should I go straight forward into space and hope to find another wall to follow across the way? I stood still, feeling a crush of people near me, but miraculously they didn't hit me. They surged around me, repelled by my cane, by my blindness. I knew they thought they were doing me a favor by getting out of my way but it was so isolating. A white cane is a barrier. Sometimes I wondered whether the writer H. G. Wells might have had vision problems that led him to write *The Invisible Man*. It doesn't take science fiction to render someone invisible. Ironically, carrying a reflective five-foot-long white stick will do the same thing.

I decided to leave my wall and let it lunge around the corner without me. My mission was to walk straight across the mall. I stepped into what felt like a void, following my cane. I was in an open space, could sense high ceilings and, given the interesting echoes, guessed that the next wall would be a distance away. Within moments though my cane found an obstacle and tentatively I stepped around it. A column. Back into the void. Another obstacle. I sidled past, saying sorry because I thought I may have tapped someone sitting on a bench. I was out in the open now feeling scared and vulnerable. I wondered about turning back but I willed myself forward. I knew Alexa wouldn't let me come to any harm. Next I heard a sound above the general hubbub of the mall. Like a pan of sizzling bacon but without the accompanying smell. Or maybe it had started to rain outside and this was a downpour

drumming on the mall's glass roof. I listened for distant thunder. A spray of water in my face had me confused. Was the mall open air now? But then I had to shift my sense of reality again, realizing I was near the fountains in the middle of the shopping center. This was the way I worked now. My brain on the alert for signals to guide me. Then a process of interpretation and construction, then reinterpretation and deconstruction. Images erected and torn down in milliseconds in my mind's eye. It was exhausting work.

"You're going to find a place to eat now, John. You're doing great." Alexa's voice was calm beside me. I wondered for a moment why she had chosen this field of work, whether she had a personal stake in the world of the blind or whether she crossed that bridge into the sighted world at the end of each day without a backward glance. I didn't need to find out. I liked her practical nature. She too had a sense of mission, of purpose. She wanted to equip me as best she could before I crossed over to that other world forever.

I thought back to the person I was when I had good vision and visited this mall and cast around in my mind for cafes and coffee shops. I had a vague recollection of a sandwich shop but not enough to build my mental map upon. I would have to ask someone. Of course I could have asked Alexa but that would have been cheating, training as I was for the days when she wouldn't be around. I was a social person, but asking for directions of a sighted stranger filled me with terror. First, I had to find some-one to ask, easier said than done in an impersonal place like a mall, with people bustling about their business in all directions. I decided to stand still with my cane sweeping in small arcs in front of me. Next, I listened for footsteps coming toward me, hard to do with all the echoes, and then I said, "Excuse me." Twice I mustn't have said it loud enough, or misjudged the moment to speak, but I felt my potential direction-givers walking straight past me. More

distinctly this time I spoke up. "Excuse me?" I sensed someone slow down and stand in front of me. I imagined the person looking me up and down, warily, taking in my cane and blindfold. I hoped he or she didn't think I was about to ask for money. "Could you tell me if there's a coffee shop near here?"

"Oh, sure," a woman with a young voice answered. "It's over there." As she spoke her voice grew muffled and distant, and I guessed she was turning around and speaking to me over her shoulder while pointing out the coffee shop.

I paused. "Sorry, where?"

I sensed the woman turning back to me. "There," she said. Maybe she was pointing again. "Straight in front of you, then on the left. You can't miss it." Then she paused. I could hear her clothing rustling as if she was moving from one foot to the other. "Keep going forward. It's not far. Four stores on the left."

"Thanks," I said. I felt annoyed at the woman, but I pitied her, too. At least she had realized that her directions were not that clear to someone who couldn't see. She just didn't know how to correct them or how to make things better for me. I had sensed her hesitation. Was she going to take me by the arm and drag me over there? Instead she had opted to flee from the worrying situation.

I didn't blame her. I had discovered that sighted people are bad at giving directions. Even before my vision loss if I'd asked directions of someone often I'd have to ask three or four times. And not just me. People seem to think that it's their job to send people just a little way forward along the right path and have them ask again. The worst thing people do when giving directions to a blind person is to point. "It's just over there," they'd say, not realizing that I have no idea of where "there" is. So I'd ask again and they'd say, "Just behind me," when I had no clue as to which way they were facing. Or they might say it's straight ahead, which is

hard to get right for a blind person. Then there's the classic, "Go around the corner and you'll see it" as if some miracle worker is curing vision loss in the mall today.

I stepped out into the void again, trying to go straight ahead, but without any walls to trail I wasn't sure how well I was doing on this. My main hope was to just keep walking and then to smell the coffee as I got closer. It wasn't the best way, maybe, but if I ended up at a coffee shop then surely that was what mattered. Winging my way forward. Wasn't there a song about a "wing and a prayer"? This sounded like my situation exactly.

After what seemed like too many steps to be described as just in front of you, I had the sudden impression that I had moved from the vaulted center of the mall to a corridor. Noises were louder, people pushed closer to one another and to me. I had made it across the mall to the other side. Now I just needed to count stores on my left. Already I could hear the hissing of automatic doors so that was one store. I knew from past experience though that stores may have more than one set of doors, which can be confusing when counting stores. They also have racks and bins of bargain clothing and goods outside so I was on high alert for anything my cane might be trying to communicate. Three sets of doors later and one long opening, and the smell of coffee hit me. It smelled good. But more than that it felt like home. I picked up the pace a little and immediately stumbled over something that my cane had missed. Its sweeps across the floor were like searchlights. Things fell in between sometimes. I was not to be daunted, however. I was almost there.

It felt like sweet victory to walk into Starbucks and pull the rich aromas of coffee, chocolate, and caramel into my lungs, but the reality was I knew the battle was barely half won. I still had to find the back of the line, order my drink, pay, and hope for a seat. All things that once had seemed so easy.

"I'll grab that table," said Alexa. Relief swept through me, surprising me. Until that moment I hadn't realized how exhausted I was, but the thought of sitting down, sipping coffee, and not thinking for a while struck me as a really good plan. After all, if I'd been getting coffee with a friend, one of us would have ordered while the other saved a seat.

For a minute or two I stood listening to people place their orders for decaf nonfat mochachinos to get a sense of the flow of the place, then I moved forward and joined the line. "Is this the end?" I asked someone's back and got a grunt in response that I took for a yes. Alexa and I always ordered one black coffee for me and one green tea for her. Nothing added, nothing taken away. We took turns paying. I pulled out my wallet after resting my cane against the countertop. Counting my money was one of the things I was learning about in Orientation and Mobility. I folded different denominations of bills in different ways so I could tell them apart by touch. It wasn't a foolproof system, as I had to ask someone in the first place which bill was which and, of course, in stores I'd be given bills as change, which I just stuffed into my wallet. I didn't want to draw more attention by standing there doing origami at the register. I found I'd had to learn to trust people more since losing my sight, and it was good to find out that most people were more honest than we give them credit for. Or maybe stealing from a blind person is really low down on the list in even the most hardened criminal's mind.

I handed over money and received two drinks in exchange. When the server asked how I was doing, I managed to rein in my response to a "Can't complain, how about you?" I'd learned from experience that they weren't looking for human connection or even a conversation no matter how badly I needed it. I'd get my solace in a cup of steaming black coffee and the knowledge that I had walked across the mall alone and bought a cup of

coffee with the assistance of only one person. It felt monumental. It was not helpful to think that only a month earlier I would have done this in a tenth of the time it had taken me today, would have accomplished it without thinking, certainly without sweating, and would have driven myself to the mall and back. In moments like these when I felt I might fall prey to overwhelming feelings of depression, I was glad to have Alexa with me. She knew the words to keep me positive, to keep me thinking forward, to focus me on my achievements. There was no talk of loss, of before, of disappointment, only of winning this race against time. I wished I could see her more than three times a week.

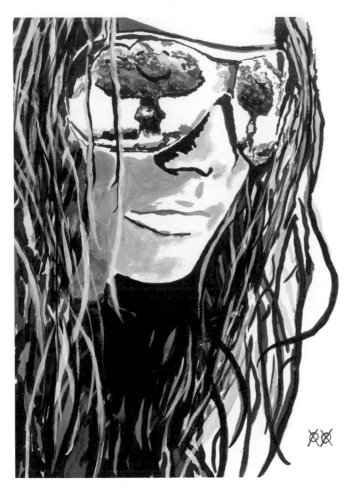

Sunglasses 2

Preparing for a Future of Darkness

When I was first told I would undoubtedly lose my sight, I hoped that the diagnosis was wrong. But in my heart of hearts, I knew it was true. My next thought was to try to see as much as I could before my vision left me for good. But even as I had this thought I knew it was a strange one. What did seeing a lot mean? Maybe looking closely at one particular object or painting and absorbing every last bit of detail. Or could it mean confronting myself with vast amounts of material—films, museums filled with artwork from all eras, architecture, nature? Should I travel and take in things I'd never seen before from around the world? I didn't know. I moved between extreme paralysis and intense action. I started with the screen-magnifying technology that Dr. Fleming had recommended. It enlarged my college texts seventy-seven times, so I could read them, word by enormous word on my computer screen. I was determined to finish college. I lived between keeping my life the same as it had always been and planning for the future. But I also toured gardens to take in summer flowers, their shades, their mass of color when viewed as a whole contrasted against their individual fragility. I needed beauty in my life and pulled their heady blossoms and exotic hues into my weary eyes

and soul. Could I have been thinking about the painter Monet, whose sight deteriorated toward the end of his life and whose exquisite impressionistic water lilies changed from ethereal white blooms to depressing flowers in shades of drab yellow as cataracts obscured his vision?

Even while I prepared for a future of darkness, I hoped it wouldn't ever come to that and blithely bought myself an enormous fifty-four-inch television. I hoped that one day I would laugh at the absurd size of the screen taking over my entire den. In the meantime I watched old movies, characters blurring across the screen, their words resonant with new meaning. I remembered when, as a kid, I recorded movies with just the sound and pieced together the plot from the words. I hadn't thought it was a skill I would need one day. I stared at so much art in museums that I began to wonder if I thought that practicing the way I looked or saw would slow down the encroaching blindness. Then there were the days when I felt the absolute opposite and I stopped looking at everything because I was scared of using up all my sight at once, as if my eyes ran on battery power and sometimes I had to let them recharge.

It was a confusing time for me. One day I was mourning my sight while I still had it, and then chastising myself for it. Other days I decided it was better to pretend that it was all gone and focus on getting around without it. Those were the days when I practiced with my cane even harder than usual. In this way I managed not to think about what it would mean to lose my sight. I was so busy either seeing too much or learning not to see. Back and forth, I embraced my sight, then dismissed it and did everything I could to focus on ways to adapt to my coming blindness. I never thought about the blindness itself. It was something to be worked around. It was all about learning new ways of being, of perceiving, of continuing some semblance of my life. No one ever said

to me, "Let's talk about being blind." And if someone had even mentioned it, I would have said I was too busy to listen.

During the day I crammed in all my classes. The work took longer with the screen readers, but I was determined not to fall behind. I socialized, struggling to lunch with friends or grabbing a beer in the evening. I also had my Orientation and Mobility training three times a week. And in the small hours of the morning, when everyone else was asleep, I took to wandering the streets with my cane, training in the dark so the light didn't bother my eyes. There were less people around too and less traffic, so it felt easier, calmer, as if I was on a beginners' course and would work my way up to real life eventually. At first I kept close to home, tracing and retracing my steps around the block near my apartment, praying that I wouldn't bump into anyone I knew—literally. Soon, however, I struck out for farther practice grounds away from the university area, trailing walls along sidewalks, listening for occasional traffic. It felt good to be out there with a sense of purpose, checking all the right boxes, doing everything I could. It would all be fine, I told myself. I didn't wear my blindfold over my eyes at night, as the darkness was soothing. I could see very little, just my cane glinting ahead of me, the occasional light in a window or car headlight on the distant highway. In some ways I had moved the blindfold to my mind. I could think about only one thing, about being independent. If I trained enough with my cane, everything would be fine when my vision disappeared completely. As if being blind was just a practical issue. I never thought of it in any other terms. I walked the streets every night that I could between one and five in the morning. When I made it home I collapsed into exhausted, dreamless sleep and rose a few hours later to start in on my day. Classes, friends, training, and night walks. No time for thinking.

Frog and Flower

Leap of Faith

Alexa announced, "Today you're going to cross the street yourself. You're ready." I paused in the open doorway, stick in hand, feeling light-headed with panic. My face must have registered some of my inner turmoil because Alexa laughed, kindly. "Come on, you'll be fine." I followed her down the steps, thinking about what was to come. It was only when I reached her car that I realized that my cane, my brain, and my feet had taken me where I needed to be without any conscious thought on my behalf. The journey had become second nature. I told Alexa and she replied, "That's great, John. You're getting it really quickly." She sounded pleased, proud. Obviously she'd seen this happen before countless times, but for me it was truly amazing that my mind could take in information from the cane, from my sense of touch. And I had visualized it. Even while I was thinking about crossing a street, had actually seen myself standing at a crosswalk with my cane waiting for a car to pass, another part of my brain had focused on signals being transmitted along different neural pathways.

We drove for a while. I imagined that Alexa was looking for a quiet back road without traffic somewhere for me to practice, but when she parked I could hear the rush of street noise all around. I assumed we'd walk somewhere else, but no. Alexa had already

found the perfect spot for me: a six-lane highway in downtown Dallas, three lanes of traffic in one direction and three lanes of traffic in the other. Then on the next corner another six lanes with three lanes of traffic surging away from us and three lanes of traffic hurtling toward us. Just standing in the midst of it at the intersection, the semitrucks passing by shook the ground so much I could feel the rumble deep down in my chest. Motorcycles and cars zipped by, so close it seemed that we could reach out and touch them—if they didn't touch us first—and the heat of metal and sweetly sickening smell of exhaust corroded my lips while my stomach churned with a toxic mix of exhilaration and terror.

Alexa's calm voice told me that the other curb was out there and I believed her because I trusted her implicitly. It just seemed an impossible distance. I felt stranded on an island for the blind. Life itself seemed to be just across this stretch of roadway and while the actual distance was short, it was a stretch of asphalt riddled with all the difficulties, dangers, and shortcomings of being blind. The sheer dread of this new life had presented itself to me. I choked on it and tasted exhaust fumes.

With the roar of trucks in my ears, I fought down panic. I was reminded of the video game Frogger that I had played as a kid in the hospital. In the game you have to jump your frog this way and that to get him across the road without getting squashed. I was never good at that game, and it never ended well for my frog. This was probably not the best time to think of this.

I took a deep breath and wished I hadn't as I sucked in more caustic fumes. The only way for me to get off my island was to cross this six-lane highway and the only way to do that was to remember everything that Alexa had ever taught me about crossing the street. And to trust my white stick.

I started to listen carefully to the sounds of the cars and trucks in front of me, the way the gears cranked as they slowed down at

the intersection, the hum as they waited at the light and the corresponding engine surge from the traffic on the parallel street. I let the stoplight go through two cycles, straining to take in all the information I could, working out if anything different happened the second time. I could see the cars and trucks in my mind in various colors, not an exact copy of the real world beyond my blindfold but an adequate copy, one that would get me across the road. I tapped my stick to the left, to the right, and back to my left to draw the attention of drivers at the intersection just as Alexa had taught me. Then I stepped from the curb into the street. Even though it was a step that was taken only after very careful consideration, it was still a huge step of faith. Like that first walk on the moon when all the research and preparation has been done and everything should be fine, but there's the possibility that you'll fly off into outer space unable to ever get back.

I walked in front of three throbbing lanes of impatient traffic, hoping I was going in a straight line. I wished I could run, or bolt, for safety but my training had been precise and specified the need for calm, for assurance, for extreme concentration at all times. I made it to the center just moments, it seemed, before the cars behind me set off and barreled over the crosswalk where I had made my careful way such a short time before. Somewhere inside I registered relief but only slightly as I had to now do the same thing again. I was in the middle and retreat was as difficult as going forward. I listened again to the car engines, signaled with my cane, then stepped out and struck out for shore. I had left my island of the blind behind. But I realized it wasn't as simple as that. It would be with me everywhere I went as soon as my sight was gone, and while certain actions would most likely become simpler for me over time, the fact of my vision loss would never go away. I would constantly be striking out from shores. And swimming upstream.

Six Shots

The Blue Painting

I could no longer use the magnifier. I hadn't used it for a few days, and now, turning it on, I stared at the screen and saw nothing. I blinked and squinted, fiddled with the controls, but nothing changed. My vision had rapidly worsened. I knew right then that I was going to lose my vision completely, that all my hoping had been in vain. Looking across my room I could make out the chairs and a table, free-form objects seen through a haze, but I couldn't see words on a screen, even words magnified seventy-seven times. This depressed the hell out of me. I grabbed my cane in anger and went outside into the twilight to walk. I heard Net calling my name but I ignored her. I wanted to be alone.

Just the week before I had invited some friends over to my apartment to study. We'd been learning about Color Field paintings with their large flat planes of solid color spread across a canvas and their place in Abstract Expressionism. It was an area of art I knew little about and we'd set up images of different works by Barnett Newman, Kenneth Noland, and Mark Rothko on my computer and were projecting them onto my huge TV screen. We were supposed to be questioning whether Rothko could really be included as a Color Field painter, but I was staring at the screen,

my nose actually touching the screen, at an image of Barnett Newman's painting *Who's Afraid of Red, Yellow and Blue?*

"Can you see color still, John?" my friend Dee Dee had asked. "Sure," I said. "I can see this is blue." Everyone was quiet. It turned out that the painting was red. In the silence that followed I could practically hear the clanging of another nail into the coffin of my sight. If I couldn't see red on a fifty-four-inch screen right up in front of my nose, then I couldn't really see color at all. I hated Barnett Newman's painting with a passion. But I did feel a sense of kinship with Mark Rothko. I learned that the bright reds, oranges, and yellows of his paintings from the 1950s later gave way to dark greens, blues, grays, and blacks. By the 1960s, and his final paintings, he was painting endless bleak landscapes in gray and black with white borders. It was the kind of vision of the world I could understand.

My friends quickly finished their study of the paintings even though we had spent a lot of time setting everything up only twenty minutes earlier. They were embarrassed, unsure of themselves. I know Dee Dee was wishing she hadn't said anything at all, and the others were probably thinking the same. Usually people avoided talking about sight or seeing around me. If out of habit they said something to me like, "Have you seen the new store" or "Have a look at this," they would suddenly stop short with embarrassment, then rapidly change the subject. I didn't know what to say to them. I didn't know how they should act around me either. I just felt the distance between us grow wider, the distance between my friends and me, and the distance between the old me and the new me.

Being out in the dark with my cane was a comfort. I was alone. I was independent. There were no words to read or colors to see. Just darkness as far as the eye could see. Or couldn't see.

For weeks I had expected to wake up and be blanketed in darkness, for my vision to disappear overnight. But it didn't happen like that. I could still see to a certain extent the familiar objects of my apartment, and outside I always had my cane. Or my stick, as I often thought of it. For training purposes, not because I needed it. I was pretty proud of how I was getting along, of how my sight was still holding up.

I headed off to meet a friend for coffee and, as I was a little early, decided to take a different route. It was a beautiful day and much nicer to be outside than in. I strolled along a sidewalk I didn't know, taking in sounds along the way, my cane skittering out in front of me. This wasn't the way I'd been taught to use it and wouldn't be the way I'd use it if I were really blind, but I was going through the motions, sweeping back and forth without paying much attention. If there were something small I couldn't see on the sidewalk, a twig or discarded bottle, then the cane would alert me to it. The rest my eyes would catch. Or so I thought. Immediately I walked along the empty sidewalk face first into a huge tree. A tree that I had not seen even though it was bigger than I was. I stood in disbelief with my face among its branches. Just as when the car had almost sideswiped me a couple of months earlier, I wasn't focusing on the pain, on the trickle of blood I could feel on my forehead. I just couldn't get around the fact that my eyes couldn't see a tree.

I began to understand that the images I was seeing were images from my mind. The more my vision deteriorated, the more my mind compensated and projected its own museum of images. This was fine as long as this gallery of art corresponded to the reality of the situation, such as in my apartment when I looked over at a murky object and saw my blue sofa complete with cushions. Or at a stoplight when my concentrated effort conjured up cars

and trucks in my mind's eye. It didn't matter that I saw a green car instead of a red one. I just needed to see a car. But when my mind threw up an idyllic vision of an empty sidewalk dappled with late-day sunlight and shadows instead of an enormous tree, there was a problem. In this case I was lucky that the tree had not been a truck.

I stood beneath this tree that had made me see sense, gripping its solid trunk as if to absorb the entire meaning of the situation into my body, into my brain, so that it would fully understand. I imagined this was how Newton felt as the apple fell and a simple everyday act became pivotal to his understanding of the immense meaning of gravitational pull. For me it was no less. I stepped back from the tree. I could not truly see it in front of me in a conventional way. I could see it in my mind, could construct its image from the details I knew. A terrible thought struck me. If I couldn't see this tree, then what could I see? Not words, not color, not form, shadow, or substance. I could detect light in the same way as when someone closes his eyes and can tell that there is a light on in the room. Nothing else can be seen, just the presence of light. At that moment under the tree, I realized that that was pretty much all I could see anymore.

The next week, three months after my first visit, I went back to see Dr. Fleming. When I walked into her office this time, for all intents and purposes, I was blind. I knew this but an irrational glimmer of hope still lived in me that one day my vision would return and everything would be fine. When I saw Dr. Fleming again that sliver of hope was taken away. From 20/400 my vision had slipped to 20/900. Now it was at a point where it could no longer be measured. My vision loss was total. I was officially blind. Not just legally blind or twice legally blind but irrevocably and permanently and completely blind.

In reality there was no difference in the day-to-day details of my life between the time when my vision loss was not complete

and the time when it was, but the two places felt like worlds apart. Like very different places on the map. I had gone into Dr. Fleming's office with the vestiges of sight but had exited as a blind man. But it was my hope, more than my sight, that had been extinguished.

There was no doubt anymore about whether I would lose my sight. It had gone forever. I quickly sank into a deep depression, greater than anything I had ever known with epilepsy. Life with seizures is a stop-and-start life. I would consider myself well whenever I wasn't seizing, view the seizures as temporary inconveniences. Blindness, on the other hand, was total, permanent, and forever. It wasn't going anywhere. It showed up one day, made sure you knew about it, and reminded you constantly of its presence.

The depression was constant, too. It seeped into my bones, my soul, taking the emotion out of everything. My life continued at the same frantic pace as before with classes, friends, and mobility training, and on the outside perhaps it seemed as if nothing had changed. But for me there had been a drastic change inside. I wasn't in training for the future anymore. The future was now and it was a grim reality. I went out with my friends, laughed at their jokes, drank beer, got myself back and forth from my apartment to school, continued with classes, but it was as if I wasn't there anymore. Some very essential part of me had disappeared.

I found I needed to sleep less now that I was blind. This could have been a combination of sheer anger and terror coursing through my body, but I was up every night, pacing, listening to music and the torrent of thoughts rushing through my mind. These thoughts were circular and hopeless, looping around in those still hours of the early morning when everyone I knew was asleep. They ran something like this: I'm struggling in school, I'm getting Incompletes, I'm going to fail. Again. And then what will I do? How will I get a job? How will I be able to afford my

own place, be independent, not be a burden? At this point in my reasoning I'd be overwhelmed by suffocating panic, rising in my chest and beating at my ribs, and the future would be a long dark tunnel with no light at the end. I could barely remember what light looked like. Sometimes the panic would claw at me, and I'd feel that the only way to end it was to somehow turn on a light, that everything would be okay if I could get rid of this unrelenting darkness in my mind.

My depression became a physical thing that squatted on me inside and out. It was black and dark, a heavy weight oppressing me. It was life without hope. I think if anyone had asked me before I went blind what hopelessness would feel like I would have said emptiness, a sense of melancholy, almost a poetic feeling. But it wasn't like that. For me it was an ever-present deadweight pressing down on me, stopping me from breathing, keeping my thoughts, my spirit underground. Sometimes this feeling overwhelmed me for days. Then I would go through the motions of my life. As if I was living in the third person as someone who wasn't really me. Like a stand-in or body double.

I did all the things I was supposed to be doing but it didn't make a difference. I went out with my friends because a therapist told me that being social would help. It didn't because of the huge disconnect I felt, but I continued anyway, hoping that maybe the alcohol would get rid of the negativity running through my mind that my friends couldn't chase away. I asked Net if I seemed depressed to her, and she said that I was coping really well. Was it any wonder that with my friends I felt lonelier than ever? They didn't know how to reach me in this place I had gone. It wasn't just about being blind, although that was a divide that was hard enough to cross. I had gone elsewhere, too. I was living in a place where life had no value or meaning, where nothing new could

ever be accomplished, where clocks had no hands, and people were destined to always be alone. It made me furious.

The suicide rate for people who have gone blind is very high, and I thought about death on a daily basis. I wanted to put an end to this life I was living in the third person. I was out and about around the college campus, active in mind and body, but it wasn't me. When I thought of my future, I just felt panic. Or I saw myself sitting in my apartment in the dark, excelling at sewing buttons onto my shirts, graduating one day to darning or even knitting, and being presented with Orientation and Mobility awards by other depressed blind people. He's doing very well, despite everything, people would say about me. I tried not to think about dreams I had nurtured of finishing college, of continuing with creative writing and becoming a teacher. It was too depressing. My life had become a video game in which I was down to the last player. I didn't feel invested in it anymore. I wanted to let the player die and add another quarter and start over. As that wasn't an option, death seemed like a good alternative.

But no matter how much I thought about it, I couldn't kill myself. The thought of the pain my parents would go through stopped me in my tracks. I remembered my mom on the phone sobbing and handing the phone to my dad. I remembered my dad's voice shaking. I couldn't hurt them. We'd been through so much together. Every time that I spiraled so low that I thought about suicide, I would end up resolving to get to a place where I could find a job and become independent. It was a tiring cycle but it kept me going forward, thrashing through the darkness in anger and isolation, determined to find a way through.

Longhorns

Seeing Saturn

One of the last things I saw before going completely blind was the planet Saturn. The astronomy teacher had set up telescopes for our physics class at the observatory on the edge of town where concrete gave way to fields. It was beautiful, just us and the stars. It always felt good to be out there with the sweet smell of country-side in the chill air. Good and exciting. Like we'd left our real lives behind us as we undertook a secret mission. We always started off with regular lights then switched to red to develop our night vision for the evening's viewing. Under the red glow everyone shone with a sense of energy, a sense of movement away from our normal way of life and normal way of perception into something very unique.

I carried this feeling of excitement from the red room outside to the telescopes.

When I put my eye to the cold metal of the telescope, I had a feeling of moving out of myself and along the length of metal up into the great reach of the night sky. There was a sense of vertigo, as if I was traveling a huge distance from this world to another, so far away, and yet this world was close too, captured right inside my skull by my eye and my mind. It took a moment for me to focus on what was out there in this other world, and when I did I

was light-headed. I knew immediately that I was seeing the planet Saturn. We had studied enough and read enough for me to greet those icy rings with a sense of familiar awe. But it was a gut feeling, too. The planet glowed yellow, churning before my eye, and I took it all in greedily, this image of something so immense, so beautiful, so extraordinary showing itself to my eye, to me, right in that second. It was as if nothing else existed in the universe except for me looking at Saturn.

I was completely aware of the full majesty of the moment, of this unique structure hanging out there in space—a structure that the planet Earth could fit into many times over—reflecting light that my eye could see millions of miles away. I felt a sense of honor that I was looking at it, a sudden appreciation for the mystery and beauty of the universe, a touch of amazement that I'd had a chance to see something so special. I soared above the messy reality of my life as I gazed at this object of such beauty, permanence, objectivity. It was hard for me to move away from the telescope.

The planet Saturn is one of the last things I remember seeing. Really seeing that is. Within a few weeks of looking at Saturn through the telescope, I was completely blind. My sight irrevocably and permanently gone. The planet still loomed in my mind's eye as perfect as it once was but a memory now. An image of something from the past. From my past.

In the weeks that followed my complete vision loss, I continued with my physics class but the joy of looking through the telescope was no longer there. I listened to the lectures still but the observatory excursions were now beyond my scope. They had become a written exercise instead, a means to a grade rather than the start of an inspirational journey. Yet the image of Saturn still burned in my mind. In some ways it should have been a symbol of everything I had lost, a reminder that I would never see again,

but instead of hating it I nurtured this visual memory. It resonated with layers of meanings that I couldn't quite grasp. Perhaps it reminded me of the person I was just a few weeks earlier and told me that, if I was still capable of the same thoughts, dreams, and memories now, it meant I was still the same person inside. Only my vision was different. I took my thought process one step further: If I could still see Saturn, in my own way, surely that made me a part of the visual world. The planet became my tenuous connection to my former self and to the world of the visual, and it gave me comfort in a world where seeing is believing. I remembered again the excitement of looking through the telescope and entering a world of new perceptions with the whole universe opening up its endless possibilities before me. More than anything I needed this feeling in my own life. The image of Saturn gave me a flash of hope amid the bleak anger and frustration I felt. It revealed a whole universe to me at a time when my own world had been torn down. I just had to figure out how to get there.

Chanel No. 5

Blind

I opened my eyes and blinked, then opened them again. I sat up suddenly, my arms lurching in front of me, and scrambled to my feet. My head hurt. I didn't know where I was but, worse than that, I couldn't see anything. I groped in front of me, felt something soft, a chair or sofa maybe. I ran my hand along the back of it, walking unsteadily. I could hear the sound of the TV and I moved toward it slowly through gauzy darkness. The layout of the furniture told me I was in my own apartment.

I stood still for a moment trying to remember something about myself—my age, my birth sign, my favorite color or song, as if, through this process, I could navigate my way back to myself. But my questions were lost in the shadowy confusion of my mind and I was left unpinned and disoriented, without coordinates on a map. I felt as if some essential part of me was missing, or it existed just beyond my grasp.

"Net?" I shouted. "Net?"

I staggered into the den, needing to lie down again. A streak of pain shot through my skull, then burrowed deep inside as if it were something alive, gnawing its way through my brain. I gagged.

"Net?" My voice rasped, barely a whisper.

"John, I'm here."

Net's voice appeared from behind me and I swung around.

"You look like hell, John. Are you okay?" I felt her hand on my arm, leading me, and I followed.

"Sit down. I'll get you water. You must have had a seizure."

I did as I was told, sinking, exhausted, into a chair, letting the sound of the TV wash over me. A late night news show, the anchor's voice cheerfully delivering doom to those still awake. A thought came to me, a memory of something important, but I couldn't quite seize it and it worried at my mind like a word on the tip of my tongue. I closed my eyes and dozed and was wakened moments later by Net pressing a glass into my hand and helping me raise it to my mouth.

"I was upstairs, John. I didn't know you were home until I heard you call. When did you get back?"

"What day is it?" I asked.

"Thursday."

It didn't mean anything to me.

I tried to remember something from the day—had I been to school or out with friends? Had I been drinking? Images jumped into my mind but they seemed flattened somehow, devoid of emotion, like someone else's vacation photos, and I couldn't tell if they were real memories or not. I felt as if I were hovering outside myself. And all the time there was the pain in my head. And it was dark.

"I can't see anything." I collapsed back into the chair.

I heard Net hesitate. "I know," she said. I could sense her looking at me, sizing me up. She pushed the glass toward my mouth again. "You're blind." She said the words in a rush like taking off a Band-Aid.

I nodded. It was a shock but not a shock. Somewhere in my brain I knew that I was blind, I had just momentarily forgotten. I let myself remember, the news sinking in with a dreadful weight. I was blind and epileptic. I turned away from Net, shoving the water back at her. I was a blind epileptic thrashing around in the dark. Regaining consciousness only to discover anew my weaknesses, my shortcomings, my miserable life. One of these days the seizures would kill me. That wouldn't be suicide; it would be a natural death. No one would assign blame or feel guilt. They'd probably think it was a blessing. I hoped it would be soon.

Coca Cola

Six Flags

Net had moved away to the Texas Hill country and I was alone. She had fallen in love, and I was happy for her, happy that she no longer needed to hide her sexuality, but her departure made me lonely. The big, empty apartment became a cage to me, a prison, but in some ways I didn't want to leave. It was familiar. I had strung red lights across the ceilings so my eyes wouldn't hurt, and I knew how to get from room to room without bumping into anything. I had mastered the appliances in the kitchen just enough to make lunch or dinner without setting myself or the room on fire. And if I did, I knew where the fire extinguisher was located. In fact, I had carefully organized the entire space so that everything had its own place that was filed away in my mind, a veritable Dewey Decimal system of possessions. My music was always within reach and almost always blasting. I liked to hole up in my apartment whenever I could, sitting on the couch with my dog Ann. It was easier there to pretend that life wasn't so futile or complicated and, with Net gone, I didn't have to be social. Part of me wanted to hide out forever, skulking in darkness and anger like some underground thing. Like some kind of hibernating ostrich burying not just my head in the sand but my whole body, as if my entire former life would somehow move on without me,

would forget about me if I kept myself hidden from sight. I found it easier that way.

But another part of me wanted to get out there and be the best damned blind person I could be. My frightened thoughts skittered along: You're blind. You're not just an epileptic but you're blind, too. You've got to get out of this dungeon and kick some ass, otherwise you'll still be here in twenty years. Except you won't be. You'll be at your parents' house being a burden in the basement. And these thoughts would get me moving. I would vow to be the best blind person ever. As if there was some kind of blind exam where you got tested on how well you could cross the street or flip an omelet. Or tested on how many horrific blindisms you committed, like sitting in a room in the dark instead of turning on the light. Or not looking someone in the eye when talking to them. I would be the perfect student.

I'm not sure whose idea it was to go to Six Flags, but I seized on it as if it could bring me life. Or light. It might not seem to be the most obvious match in the world—a blind man and a season pass for an amusement park—but in my mind it was the perfect place to train with my white cane. There was something else, too. Whenever I thought about Six Flags, I felt good inside. It reminded me of my childhood, of feeling happy and secure, and I definitely needed some of that old magic back in my life.

The first time I went there after losing my sight, a friend drove me, and we walked to the entrance together in silence. It was a momentous occasion for me. Part of me wanted company like old times, but when my friend hugged me goodbye and wished me luck I knew it was right that I should go on alone. In the heat of the day, the smell of asphalt walkways and asphalt from some of the ancient old rides wafted toward me. This familiar smell of tar and funnel cakes, turkey legs, and popcorn took me right back to when I was a kid, and I felt that surge of excitement, as if you're

standing on the cusp of life and can't wait to jump on in. Nothing holds you back as a kid. You live in the moment even if you're pretty sick like I was. Or especially if you're pretty sick like I was. Then you learn to grab hold of the good days and ride them hard, because you don't know when you'll get another day like it.

Those feelings from my childhood swept me forward through the gates and into the park. They gave me a sense of purpose along with my sudden happiness, and I decided again that I was going to train hard. But it was difficult not to be frustrated with my five-foot-long stick tapping in front of me. It seemed to take the fun straight out of the day.

I was right about the park as an excellent training ground. Everywhere I turned there was some new kind of terrain for me to face, a challenge at every step: cement walkways, then asphalt, then wooden, each requiring new levels of concentration. It was hard to know what to expect from my cane. I had been taught to feel for certain vibrations to help detect the way a surface sloped or dropped away, or to feel out objects in my path, but it was hard. There was so much to take in. My cane had a special tip that was supposed to help me feel the texture of the pavement more easily. But I felt the information came too late to be helpful. And there was so much of it. I didn't know what to do with it. There were stairways and bridges and elevators and noise, music, and energy everywhere. I crashed into things all the time or tumbled down steps that had appeared out of nowhere or bumped into doors that opened in my face. This was much harder than I'd thought, much harder than walking around downtown. It was definitely an advanced level course.

Soon I was covered in bruises and scratches, and that was nothing compared to my ego. It was quickly mortally wounded and on the verge of quitting. Whose stupid idea was this anyway? And then, just when the shiny memories of my childhood had

slunk away and I was left only with the pure rage of a blind man wanting to use his cane as a weapon, the sheer genius of training at Six Flags became apparent. I struggled my way to the top of a ramp and the front of a line, handed over my cane for safekeeping, clambered gracelessly into the car of a roller coaster and strapped myself in. I sat for a few moments, sweaty and irritated, and vowing to storm out of the park and never come back as soon as I was done with this ride. And then the car moved, inching forward up a steep incline, and I forgot everything except anticipation. Nothing blows off steam like a roller coaster. I left my anger behind at the bottom of that first hill and I laughed and screamed with the best of them, my body hurtling through space, no longer defined by my limitations. All around me people were experiencing the same thing as I was, their eyes tightly closed, every sensation now physical not visual. And for that moment it didn't matter that at the end of the ride they would open their eyes and see.

As the ride slowed to a stop, I unbuckled my seat belt and stepped out of the car, weak and relieved, still laughing like everyone else. I reclaimed my cane and moved down the steps, my adrenaline flowing. I was ready to conquer another round of angry frustration just to feel the emotional high of the roller coaster. I set off again. I stumbled down the steps, bumped into a metal fence, tripped over a child or dog or something moving quickly, picked myself up, and started over again. It was slow progress. Slow and painful. But my brain was beginning to take note. I could tell that the messages from the cane to my hand and then to my brain were getting faster and clearer.

My first visit to Six Flags was overwhelming. I had so much to learn. My emotions at the park could be plotted on a graph. Happiness. Motivation. Determination. Frustration. Humiliation. Anger. Rage. Anticipation. Exhilaration. Happiness. Motivation. Determination. Frustration. Humiliation. Anger. Rage. And on

and on, looping around just like the roller coaster, just like my tentative, stumbling path around the park. Luckily I ended the day on a high note. One last turn, some sweet, sugary funnel cakes, and a quick walk through the early evening to wait for my ride home. I vowed that I would be back. It had felt good to be away from the confines of my apartment, to feel a sense of nostalgia, and to convince myself that somewhere in the complicated world of my brain something was beginning to make sense. That I was one step closer to reaching independence.

I did go back lots of times in the next couple of months. In some ways it became a kind of addiction, but a mostly healthy one. Like long-distance running or exercise. I became more disciplined at the park and pushed myself to practice my skills, to learn as much as I could and focus on my goals. Once I rode the Batman ride ten times on a day when the park was empty. That was the great thing about having a season pass. I could go to Six Flags as often as I wanted, but if the park was crowded I could leave after just an hour and come back another day. Riding the Batman ten times was fun but there was something else going on, too. It was as if I was running laps or doing time trials. There was a sense of purpose that going on ten different rides wouldn't have achieved.

Each time I came off the ride on an emotional high I returned myself to a greatly concentrated frame of mind. I was strict with myself. I focused on my cane, on what I could feel through the tip and I visualized. The stairs—six of them—led down to a wooden walkway. Ten steps across, watch out for the uneven plank of wood, past the stand selling funnel cakes, and sharp right onto the asphalt pavement. Five steps and duck your head to avoid the low branches on the pungent-smelling pine trees. I still had the scratches from last week's battle when I wasn't paying attention. The ice-cream stand was on the left—be aware of low-lying children. Each circuit I made up to the Batman ride and down again

I took careful notes of everything I could, of anything that could possibly be useful and translate into a visual rendering of the scene for my mind's eye. I carried this mental map with me on each trip, embellishing it as necessary with additional information. In reality it was more than a map, for it pulsated with sounds and smells, too. Even tastes if I stopped off to try a funnel cake or ice cream. And the more I concentrated on what my cane was telling me and then transferred the details onto the map in my mind, the more natural it seemed.

In some ways it felt like learning to drive a car. In the beginning there are so many things to concentrate on all at once, and you're actually listening to your brain giving you instructions as to what to do and when. But gradually it feels more natural, a seamless process between mind and body. It was like that with getting around at Six Flags. Little by little I could stop monitoring myself so closely as my brain just understood the messages coming along the cane from the pavement. I didn't have to step in to interpret and translate all the time.

My routes around Six Flags became second nature to me, and I became proficient enough to take in new, unexpected information. A slick pavement after a night of rain, or a shallow puddle across a walkway, no longer caused me problems. Now I would sense these dangers with my cane and have enough time to process the information and walk around them or to tread carefully.

I said that it was a mostly healthy addiction. And it was. I was genuinely trying to get better at Orientation and Mobility. But sometimes there was a feeling of recklessness too, as if I was playing truant from my life, hanging out at Six Flags when I could have been doing something serious in the world. I definitely liked being away from my apartment, which I still viewed as a dark place in my life, and so there was an underlying spirit of running away, of leaving everything behind and never going back. It could

feel mindless on the roller coasters, as if you had nothing better to do in the world and were proud of it. And I was still angry. I took to going to the park at nighttime, not for any rebellious reasons but because my eyes hurt during the day. One of the ironies of my vision loss was that my eyes were still perfect. It was the connections in my brain that were messed up, so my eyes continued to adjust and try to make images by letting in more and more light. It didn't help, of course, it just turned my eyes blood red and painful even through dark glasses. So I stalked around in the dark, angry at the world that had taken away my sight, frustrated that something as simple as walking up and down steps had been turned into such a chore. Sometimes I wondered what people thought of me as I made my way around from ride to ride. Mostly I didn't care. I just lived for the thrill of the roller coaster and hoped that one day all this stumbling around in the dark would pay off.

The roller coaster was a pretty good metaphor for my time at Six Flags with its highs and lows, its peaks and pits. The names of the rides meant so much to me. I thought of them in hushed and hallowed tones. The Double Loop Shockwave. The Titan. The Texas Giant, the Batman, and the Runaway Mine. They offered me solace from the pain of getting around. They took me out of a world that was difficult for me to navigate and threw me up into the heavens to a place where I didn't have to think. Where I didn't have to concentrate on every single step and I didn't need a cane. Some people love the fear of amusement park rides, the thought that they are courting danger. For me they were safer than the world on foot. I loved the abandonment of responsibility, the letting go of all rational thought. I could wail and laugh and scream in temporary terror. I could be blind. And none of it mattered. The rides were my reward for all my hard work, a godsend, a very real balm for my spiritual and physical pain.

Jazz Street

Technicolor Dreams

Soon after losing my sight I understood that the blind do not live in a world of darkness. While I could not see anything through my eyes, my mind still projected images and immersed me in my own personal visual world. At first it was a comfort not to stare into an endless void, but after a while the images plagued me day and night. Faces and objects tripped through my mind like some twenty-four-hour variety show or a nonstop movie marathon. There was no rhyme or reason to the snapshots that flared in my mind's eye, burning briefly, brightly, before transforming into something else. For a second I contemplated my childhood bedroom with its narrow bed rendered here in vivid colors like a Van Gogh. I hadn't thought about it in years and now it morphed into the silhouette of a tree against a summer sky and then a stream of rainbow clouds heavy with rain—or promise. If I focused too long on the images, they blurred. If I tried to rationalize them, playing psychiatrist to my own visions, they disappeared, only to be replaced by something else from the junkyard of my brain. A junkyard where everything existed in Technicolor.

The images seemed to arise every time my mind was idle, whenever I wasn't concentrating like crazy on crossing a road

or navigating an icy stairway. I read somewhere once that—for a sighted person, of course—you could induce hallucinations by taping half a ping pong ball over each eye, listening to radio static, lying back, and staring into the white void in front of you. Crazy images were supposed to leap before your eyes, your brain self-stimulating when it had nothing else to see. I never tried it, but now I had my own constant variation on this. My brain was projecting its own images now that it couldn't produce images of the visual world beyond my skull. Sometimes I could understand where the images came from: A roar from the highway sent a fine red truck with silver bumpers careening through my mind or a distant bark made me think of Ann, my beloved dog. Other times the images came out of left field, chasing one after the other, stepping on each other's heels. There were faces from my past or faces that I'd given to people newly met, based on the sound of their voices. I couldn't shut them out or close my eyes to make them go away. They were there when I dreamed, pounding in my head. I felt like I was going mad.

It made sense that the images multiplied when I was alone in my apartment and my thoughts turned inward, defenses down. When friends came over the images shuffled to the edges of my mind, biding their time. So I tried to be social by inviting my friend Kelly over for a beer, or Brooke and Dee Dee. We'd grill ribs and burgers, whip up some margaritas, and then the carnival of images subsided for a while.

My friends and I talked about their lives. They'd ask about me, about how I was doing, but I didn't dwell on it and neither did they. They seemed glad to skirt the issue and get back onto safer ground. Sometimes they'd deal with me by acting like nothing had changed. "Did you see *Ocean's Eleven,* John?" or "Did you catch that show on TV last night?" and even when they realized what they'd said, they kept on blundering forward, hoping

I hadn't noticed. And what was I supposed to do? Should I get angry at their clumsiness or be glad they thought I was still part of a normal world where people went out to the movies? And, it was true, I had been to the movies since I lost my sight; I sat in the dark theater with the sound washing over me, my face turned to the screen like a moth to light, but with my own movie playing in my mind's eye. But I hadn't seen a movie or a TV show in the conventional sense of the word for a while now.

So did I want my friends to ask if I'd seen a movie lately and then apologize for asking? Apologize for putting me through the hell of thinking about something I couldn't do anymore? Hanging out with me had become a minefield of saying the right thing, saying the wrong thing. Even I didn't know what I wanted them to say. I wanted things to be the way they were. But they weren't and they couldn't be. It was as if I had stepped through into another world where we were all speaking the same language but the meaning was getting lost.

This sense of disconnect drove me crazy, and I didn't know what to do about it. I felt it bubbling furiously in the pit of my stomach when my friends were around. I was the same person I'd always been except now I couldn't see. My brain worked in exactly the same way, but my friends were now amazed that I could do the simplest of things like feed myself or dress myself. They seemed to think of me as completely helpless. If I mentioned that I had read a book or newspaper article, they were astonished. If I crossed a street with a cane, they would ask if I could still see, at least a little. Crossing streets wasn't something that blind people could do. It was depressing. They stopped asking my opinion anymore as if they were thinking, "Well, he can't see, so he won't know." It was contagious. Soon I stopped asking myself my opinion, too. Everyone tiptoed around me, keeping the conversation neutral—no one wanted to make me mad, no

one wanted to make themselves feel guilty. People talked about me in front of me as if I couldn't hear or understand. As if my IQ had deteriorated along with my vision. Blindness had become a mental condition. And I allowed it to happen. I didn't know what else to do. I simmered in silence, fuming inwardly at my friends, not only because they didn't understand me but because I believed that what they thought about me was true.

"He'll get used to it," they said, or "It's normal for him to be like this. Who wouldn't be? He'll come around." I was sitting next to them on the couch, the "him" in question, not knowing what "like this" meant or what "normal" was anymore. Not really knowing who I was anymore.

"Hi, it's me," I wanted to yell to them. "It's still John in here." But I didn't. It wouldn't make any difference. I was too far across the divide, too far away from their world for them to hear.

When my friends moved on to other, no doubt safer, topics of conversation, I gripped my beer and listened to the rise and fall of their voices. The sound track to a life that I was no longer a part of. Behind my dark glasses I drifted back to my childhood, to my hospital room after kidney surgery. I lay in the narrow hospital bed, alone and unsure, listening to the story of *Orca* as evening turned to night. Now the whale's sad frustration seemed to echo my thoughts, and I felt further from my friends than I'd ever felt before. I wished that I was back at home with my own music playing and a rush of random images seething in my mind. Even that seemed preferable to this.

I started going to Mable Peabody's again, sitting at the bar alone, my cane a warning to others to keep away. I felt accepted there but not necessarily understood. I was different now, that much I knew. I was considered an outsider. An official member of the broken and rejected bar crowd at Mable's. But I wasn't looking for community among life's so-called misfits. I had my own

community, my own family and friends and I wanted it back. I wanted them to see me as I once was, as I still was. Until then I seethed with anger and frustration alone in my apartment or pounding the sidewalks late at night, my cane tapping out my fury, a distress signal that no one could hear or understand. I felt far away from everyone I'd ever known. But as I walked in the great empty space of night, my footsteps and cane taps echoing back to me, I became keenly aware of something else. I was far away from myself, too. I didn't know who I was anymore. I was trapped outside and I wanted a way back in.

Day of Hope

The Possibility of Hope

I thought about writing down my thoughts and being the writer I wanted to be, but I found I just couldn't do it. I sat at my desk at my computer but it seemed like a chore. The words didn't come and the dream seemed heavy now, tainted in some way, as if it could never be the way I wanted it to be. I felt more locked in than ever, images spiraling out of control in my mind.

There was a small wooden Buddha on my desk, picked up a few years ago from Voyager's Dream on the hub at the University, a store that sold stuff from all over the world and invited dreams of travel to exotic lands. That seemed distinctly impossible now. I took this Tibetan Buddha in my hands and moved my fingers slowly across its worn surface, feeling the soft grooves that defined layers of robes, the indentations of individual fingers. With just one fingertip I traced half-closed eyes, the curve of a mouth, a stippled headpiece, and saw the image of the Buddha appear in my mind's eye and chase everything else away. I stopped, startled for a moment, not only by the strength of the image but also by the sudden sense of calm I felt. My mind had stopped racing. Gently my fingers sought out the soft statue again, and as they explored, more details appeared—a slight blister-like imperfection in the wood, a two-strand necklace looped beneath the chin. Could I

have remembered these details from my sighted days? Did I even know of them? Or, crazy as it sounded, was I really seeing with such clarity with my fingers, through my sense of touch?

I stood up and crossed the room and picked up the remote control from the coffee table. Sure enough, as soon as I touched it, an image of it appeared in my mind. I petted Ann's ears and an image of the little dog popped up in my mind. For the first time in months I was smiling, feeling giddy inside. I was pretty sure that if a neurologist were to run an MRI on me right now my whole visual cortex would be glowing.

I couldn't get the image of that Buddha out of my mind. The TV was on in the background, just for the mindless chatter of it, or maybe so I could tell my friends that, yes, I did see that TV show last night. But all I could think of was the Buddha. I wanted to draw it.

I hadn't drawn a thing since I went blind. What was the point? I couldn't see where I was putting pencil to paper, so everything would just end up all over the place, lines drawn on top of other lines, out of position, out of perspective, a mad man's interpretation of the world. Or a blind man's. But I wanted to draw the Buddha anyway to get the image out of my mind, onto paper and into the world like a message from me to them. I was alive. I had a mind. I was still me.

This idea tormented me, worrying at me, and it was strange because there was the calm image of the Buddha in my mind and then there was me all knotted up inside over this idea and what to do about it. But it felt good to have a sense of purpose.

I drew the Buddha with charcoal, but it got lost between my mind and the paper as I knew it would. I felt it crumbling from serenity into disarray as I endeavored to make the careful transfer, ending up as a black cloud of charcoal. I tried not to feel frustration but to think instead about the kick of adrenaline I got from

focusing my thought process—from the sensation of touch that translated into an image in my mind's eye and then the carrying of that image from my mind onto paper. I was desperate to get that image out of my mind and to skewer it, still fresh, still alive, and present it to the outside world as evidence. Of what? That I could still perceive? That I had a mind? That I could still communicate?

I was taken over by the obsession of learning to draw again. It became the only thing I could think about, a constant hum in my brain. I was casting around for a way of making it work, but I knew that thinking about it wasn't going to make it happen, so I sat myself down at my kitchen table with bags of materials gathered from all over my apartment from various craft projects and handyman projects from my past. If my old pencils and charcoals wouldn't work, I would try other ideas. Paints, glues, epoxies, anything I could get my hands on. I had bags of materials. I started drawing with all kinds of crazy things, searching for that special substance that would let me feel my way around a drawing. I had figured that much out. Just as I needed my sense of touch to see images now, so too did I need it for drawing those same images on paper.

A couple of days later it was fabric paint that came to my rescue. When squeezed onto paper it had just the right consistency, so the lines I drew stood out enough for my fingers to feel their outline but not too much to dominate the drawing. I practiced with simple geometric shapes, squares, circles, and triangles, over and over again. I tried not to think about the things I drew before I lost my sight: exploded views of airplane engines, drafting plans for houses, cartoons, or portraits. Instead I had to think of the here and now. I concentrated on the four sides of a square. It was harder than you'd think to get the last side to touch the first. Circles were tricky, too. I was relearning how to draw. My brain

knew what to do and my hand knew what to do but now they had to figure out what to do together in this new equation with touch instead of sight. And I had to master the right way to work with the paint. In the beginning I was too impatient, drawing the next line while the paint was still wet, smudging it. My hands were thick with dried, cracked paint.

Eventually I used a heat gun to dry the paint so my materials could keep up with my enthusiasm. And then I was ready to try the Buddha. I started work in the afternoon, sitting on the floor with a big bag of paint next to me and a stack of paper. I drew a little and then crumpled up the paper and threw it on the floor next to me. The Buddha was a small statue but there were so many details in my mind that had to be drawn line by painstaking line. Face, robes, headpiece. It was a huge effort of concentration, this seeing by touch. I felt like a child struggling with long division, my brain aching to expand to combine all the right elements. I touched the statue, applied the paint, touched, compared, and crumpled. I pictured my thoughts shooting from my fingers up my arm to my brain and then down the other arm, pulsing and glowing like sparks of light, except heavier. There was tremendous effort involved, both physical and mental. I felt like a surgeon. The pile of crumpled paper grew steadily higher as day turned into night. Ann came and lay on the floor next to me.

I forgot about dinner, just kept on working on my drawing of the Buddha, powered by this sense of tunneling toward the light. I was taking something from the world of the sighted, running it through my blind man's brain, and giving it back again. An offering. Something sacred. A text translated into my new language and back again. I was so grateful for the Orientation and Mobility training I worked so hard at the past year: visualization by touch for help with daily life, for help getting around, for help finding my way forward.

When morning arrived, which I knew now not by the arrival of light but by my very loud alarm clock and the thrum of traffic outside my window, I was finished. The Buddha lived on the paper. I was ecstatic.

When I touched the drawing, I felt warmth in my chest, like the onset of a fever. Or maybe like the onset of a seizure. But then I realized it was a feeling of hope, something I hadn't felt in a long time, not something I'd even thought about much before. What does hope mean? Hope you had a good day. A good birthday. But sitting on the floor of my apartment in the dawn light with that little drawing in my hand, I understood that it meant that you have faith that something good can happen. It was a feeling about possibility. And I liked it.

This meant a lot to me as this was the year that I lost all hope. Finishing school well with epilepsy was hard enough. Finishing school at all with blindness had seemed impossible. My dream of independence had begun to seem almost futile. Now suddenly with this Buddha in my hand, I was feeling hope. I had accomplished something new for myself at a time when I thought my world was shutting down.

Scooter

Titanium White

Before I could decide against it, I rushed out of my apartment into a busy college morning, hauling myself and my white stick through the wash of students on the sidewalk, across the street, and into the university bookstore. I had one thing in mind: paints. The left side of the store held books while the other, I knew from my seeing days, was filled with aisles of art supplies. I headed into this section, pulled by the interesting smells of paper and canvas maybe, and a sharp, cutting scent that later I'd know was linseed oil.

I stood there assessing, dark glasses on, and my cane in my hand, an awkward extension of my arm like a leash without a dog. My head tilted to one side as if listening to distant music or awaiting divine inspiration. I was dimly aware that my hands were caked in paint, probably my clothes and hair, too. I hadn't slept for a very long time, and my face wore a manic smile. I wasn't sure how long I'd been standing there, but long enough for self-doubt to start seeping into my sleep-deprived brain. What was I doing here? A blind man in a paint store? I couldn't even see where the paints were, so how was I going to paint with them? What would my friends think? I imagined the gulf between us growing wider than ever, my drawing of the Buddha floating face down.

"Hey, good morning," said a male voice nearby. "Can I help you?"

"I want to paint." It's all I could think of to say, and even to me my voice sounded desperate, full of ragged need and vulnerability. I felt like crying. I turned toward the salesperson, and I imagined him looking me up and down and then slowly backing away.

Instead, he said, "Cool," and added, "Any ideas on paints?"

He sounded interested. I jumped in. I didn't know anything about using paints but that didn't stop me. I'd read a lot of art books. "I need to be able to feel the paints, feel a difference between colors." I rambled on and explained about drawing with the fabric paint, the raised lines, the geometric shapes, about the Buddha. I could ramble real well without even trying. The guy was still listening to me.

"That's cool," he said again. Cool, not crazy. "So let's try some paints. Acrylics might work, or maybe oils, something that dries thick and textured." I could sense his hands moving nearby as he was talking. He was thinking out loud really, his mind processing what I'd told him. "If you take the tops off, you can feel the paints and get a sense of them." He said it like it was the most normal thing in the world. "Try this one." He put a tube of paint into my hand and I held it carefully, reverentially. "It's oil," he added. "Titanium White."

"What's your name?" I asked.

"Daniel."

"Well, thank you, Daniel." I paused. I was about to say more but then I held back. There was too much to say. I nodded my head toward him with a slight bow. "Thanks again," I said, trying not to let my voice crack.

My stomach roiled with butterflies as I gently squeezed the tube and felt the soft, cold paint on my fingertip. I rubbed it with my thumb and noted the texture, its thickness taking me by surprise. It was like toothpaste, but in my mind's eye I saw a canvas of white: a bright white; clouds through an airplane window white; wedding cake icing white.

"Hey, try this. Put it on this paper, and you can feel it properly," said Daniel. He guided my hand to a pad of paper, and I squeezed out a larger dab of paint and sank my fingertips into it.

Immediately I felt my mind make the connection. My fingers touched and my mind lit up in white. "Wow," I said. And then to include Daniel in my discovery I added, "It's cool."

I had been transported to this world of white, this intense concentration between my mind and my sense of touch, so when Daniel spoke again he sounded distant and I had to consciously bring myself back to him, wading through Titanium White. He was suggesting more paints, different colors.

"How about these next? Ivory Black and Cadmium Red? There should be some contrast in the way they feel." His advice was practical but his voice was tinged with curiosity. I imagined him holding up the tubes for me to see, waiting for my approval. I nodded and grinned, hardly able to wait.

I sensed a weight on the pad of paper and guessed he had put the tubes there. Without thinking, I wiped my paint-smeared fingers on my pants—it's what I'd been doing all night—and picked up a tube. "That's the black," said Daniel.

"Thanks," I said. Then I focused on opening the paint, squeezing out a tiny amount, and readying myself for the mind-touch connection. The difference in texture hit me immediately. This black was slick and runny and I was thinking about squid ink or shiny black cars. I could have washed my hands in this and stained myself black as a night without stars. It was a black without light, but it felt hopeful to me as there was a sheen, a slight gleam to it. I moved my fingers around and saw my mind's eye turn dark with this pure, concrete black.

"It's different," I said. "So different from the white. I can see the difference," I said to Daniel, my voice awed and excited. At first I didn't notice the dreaded "see" word slipping out of my mouth, and when I did, I didn't feel the need to correct it. It was

the exact right word to use. I could see the difference between Ivory Black and Titanium White. I wiped my hands on my pants again and plunged my fingertips into first one dab of paint, then the next. My mind lit up like a traffic light. Black. White. Black. White. It was fun. I could have spent the whole day in this store playing with the paints. I was laughing now and I knew I must look like a crazy blind man finger painting. Hell, I was a crazy blind man finger painting. Next to me Daniel laughed and I felt him slap my shoulders.

"Knock yourself out, John," he said. "I'll be back in a minute. Try some other colors."

That brought me back to my senses. I could be having this much fun with another paint, too. Hurriedly I wiped off my hands, unscrewed the last tube of paint, and squirted. A little too hard as I feel a splurge of paint mound onto the paper. Never mind. I could hardly wait to sink my fingers into it. At the very back of my mind sat a little spike of doubt, of fear, that this paint would not feel different. But I plunged in anyway and waited to feel some emotion. At first, nothing. I panicked. Was I being too rational? Overthinking the process? How could I be spontaneous again? Could I will the color red into my mind? I moved my fingers around slightly in the Cadmium Red, still consumed with my thoughts. And as I worried, my fingers took over, circling in the paint, gently dabbling, as if searching for something. They noted that this paint was not thick like toothpaste nor slick like oil but was somewhere in between. It gave beneath my fingertips, plastic and pliable, warm and comforting, and I began to see the color red building in my mind's eye. It was a soft red that made me think of home hearths and dogs lying in front of fires, but there was a touch of the regal to it. It was a color that made you take notice and then invited you in to join it. For me this would always be Cadmium Red.

So now I tested myself. I wiped my hands off again on my paint-encrusted pants and moved from one paint to the next. Thick—Titanium White. Slick—Ivory Black. Pliable—Cadmium Red. Again my mind lit up with the colors. Wedding cake icing and shiny black cars and a roaring fire in a grate. Images that could tell a story or two. I was remembering that joke "What's black and white and red all over?" and instead of "newspaper" or "a zebra with sunburn" I was thinking "my pants" and "all the pictures I'm going to paint." Because I knew now that this was what I was going to do. I'd buy these three oil paints and a bunch of canvases and with them I'd paint my way back into the world. A world of my own making, on my own terms. No matter how long it took.

When Daniel returned he was excited that the oils had worked out. He wrapped them up for me, offering to get new tubes from the back but I said no, these tubes had meaning for me. "Sure thing," he said, packing up some canvas paper, a palette, and brushes. "You may want to get a rag or something, an old towel or T-shirt for your hands."

I laughed. "You're right."

"See you soon," said Daniel. I didn't even wince.

As I left the store I was on cloud nine, my head up, my stride long, and my cane tapping with confidence. I was thinking about how lucky I was that I chanced upon Daniel. Things could have gone so differently otherwise. He didn't question what I wanted to do, didn't think of me as crazy, he just saw me as an artist who wanted to paint. Of course he had noticed that I was blind. How could he not? Unless he was blind, my train of thought added ironically. But the important thing was that he saw my blindness as just one part of me. It didn't define me for him. I imagined him telling his friends later, "A guy came into the store today looking for paints. He was blind." Or would he say, "A blind man came

into the store today looking for paints"? There was a difference. But did it matter? The important thing was that he had embraced what I wanted to do, and he had helped me.

Once at home inside my apartment, I laid down my prizes and petted Ann as she trotted over to greet me. I was surprised to feel matted paint all over her fur and laughed. She must have been my paint rag last night, too.

Alone in my apartment I stashed my paint supplies in my bedroom. I wasn't really sure of my motives, but I thought I didn't want my friends to view me as crazy. Blind and epileptic was bad enough. Blind, epileptic, and crazy would be too much for them to bear. Or maybe I was scared they would gently persuade me not to paint. They'd tell me not to open myself up to failure, to concentrate on the things I could do, not the things I couldn't. They would take me to bars and coffee shops to get me out of my apartment, away from myself, and we would continue to make small talk as usual until the next time. But I didn't want to do that anymore. The way I saw it, things couldn't get any worse. So what would one more crushed hope matter? I'd already hit rock bottom and seen my dreams shattered. There was that "see" word again. To be precise, I hadn't seen my dreams shattered. I hadn't seen anything for a long time in the world outside my mind and that was the problem. Not in terms of me seeing or not seeing, but in terms of the people close to me. For them seeing was knowing. Seeing was believing. And if I couldn't see, they reasoned, I couldn't know anything anymore.

It was interesting that they didn't have Daniel's objectivity. They knew me when I was sighted and now viewed everything that I was as diminished. They saw me in terms of what I had lost. What I could have been. Maybe it was easier for people who met me now, not knowing my history. They accepted me as I was. It

was just that the people close to me hadn't learned to do that. And neither had I.

Sitting on my bed after stowing my newly acquired contraband in a closet, I tried to understand why I was determined to paint. Certainly I loved drawing and this was the closest way I would ever get back to it. But it was more than that. It ran deeper. It had to do with the images in my mind. In many ways I was tired of them fluttering there like exotic insects in search of a home. I was hoping that capturing them forever in paint on canvas would free my mind of them and record them for me. Many of them were memories of my past, images that I loved from my sighted life, and I lived in fear of them disappearing one day from my mind and leaving me with nothing. A desolate canvas. I wanted to get these memories down on paper to keep them forever. Thinking about these reasons it seemed that my mind was too full of the visual. I needed to declutter and archive my images and memories, both the wanted and unwanted, to leave my mind free to process new ways of seeing. In short, I needed to spring clean my mind and move forward.

My thoughts had a kind of twisted logic, even if they did rest on the doubtful foundation that a blind man could paint, but I decided to accept the challenge of this premise. I was going to paint pictures of the recesses of my mind, a personal album of sorts, writ large in red, white, and black. I wanted someone to notice and say, "Hey look, guys, it's still John in there. He's still one of us."

Today was an amazing day.

I finished my first drawing and in that moment knew that I would be able to paint.

I discovered how to see color with my fingertips.

I went into a store as a blind man and came out as an artist.

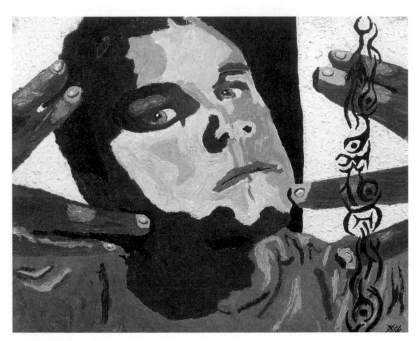

Ten Eyes

Self-Portrait

I was like a kid in a candy store with my three new paints. I set them up on a small table in my den with the palette, brushes, and paper, my heart thumping with anticipation. I even borrowed an easel from my mom without really going into details about my plans. I had an old T-shirt as a designated paint rag so Ann wouldn't have to take another bath, and I was ready to go. Except I wasn't. Painting wasn't really a jump-in-and-get-inspired-later kind of thing for me. Even before I lost my sight, I would think and plan before drawing, but now I absolutely had to. I had to conjure up mental maps in my mind's eye and physical maps on paper before I could get to my beloved paints.

I decided to make a self-portrait. It wasn't really a carefully considered decision, more a sense of knowing that this was what I wanted to do and that it felt right. I thought I would want to paint one of those images that had been floating around my brain for the last six months, so it came as a surprise to my rational self that I was set on painting my own face instead. It was also a surprise to discover that the underlying emotion to my painting endeavor was anger. Given my excitement about the prospect of painting and my newfound sense of purpose and direction, I thought I'd be painting on the wings of joy. But no. It seemed I

was fueled by great wells of rage. The three colors that had thrilled me at the paint store now took on the negative slant of my mood. The complete opposites of black and white came to represent the dichotomy of my life, the stark contrast of my life before and after going blind. Red symbolized anger for me as well as fire, and as I painted, a phrase I had heard resonated deep within me—burned beyond all recognition. It made me feel raw, as if my old life had been completely burned away, and I painted, consumed by these emotions.

I worked on my self-portrait for days, eighteen hours a day, pouring myself into it. The process was a slow one, but there was a methodical sense of progression to it, and that I could live with. I continued to go to my classes and see my friends, but I was consumed by thoughts of painting all the time. I ached to get home to my air-conditioned den, to be alone so I could get to work, feel the oil paints, and make my vision on canvas grow.

For the past year, ever since I'd been diagnosed as legally blind, my Orientation and Mobility training had taught me how to adapt. Now I took those lessons and applied them directly to painting. All those hours I'd spent learning to visualize through touch, building images in my mind while trailing a wall or the back of a chair were helping me now. Just as with the Buddha, when I put my fingers to my face, I saw an image in my mind, a detailed-in-color face that I knew incredibly well. And I saw how angry it looked. In some ways it shocked me to see myself looking so furious, but it made sense. That was how I felt inside most of the time. I channeled this fury into my work.

Touching my face was a curiously intimate process, not something I had ever really done before, and it felt as if I were discovering myself all over again. This new person I had become. At first I felt self-conscious, timid even, laying my hands on my lips, the nape of my neck, the soft folds of my ears, and seeing images

multiply in my mind. This was seeing my face in extraordinary detail: the uneven stubble on my chin from a careless shave, wrinkles beneath my eyes that I didn't know I had, the flaring of my left nostril. And the constantly clenched jaw. I hadn't realized my face had become a stone mask of tension, tilting at an unkind world. I was gentle with my eyes. I felt a strange tenderness toward them, knowing that they could still see, that it was the rest of my body that had let them down. And thinking about that, I would feel a new flare of anger at myself and at the world.

I transferred what I saw through my fingertips onto canvas, first plotting raised lines with fabric paint, creating a topographical map that showed me later where to apply my paint. These lines would be my guide, keeping me orientated around the canvas, giving me clues where to add shading or shadows, where to blend colors or highlights or dark points.

It made me crazy that everything took so long in this new world of mine, that this movement from fingers to mind to canvas was such a painstaking operation when I could see so clearly in my mind what needed to be done. But I had to get there in baby steps, mouse steps, which was so at odds with the rage inside me that wanted to splash images onto canvas and yell, "Look at what I can do." I had to keep the rage simmering without letting it boil over into chaos. Painting crazy, smeared abstracts wouldn't help me cross the bridge back into the sighted world. That would keep me squarely in the blind, epileptic, and crazy world. And my disconnection would grow. Instead I learned to fuel myself with my anger in a positive way so that I could prove a point, painting hour after hour, day after day, learning my way around the canvas, around the paints, until my message to the sighted world was finished.

I called my first painting, that first self-portrait, *Ten Eyes*. Painted in Titanium White, Ivory Black, Cadmium Red, and a

touch of blue, my face jutted forward aggressively, my chin pushing out of the canvas into the personal space of the viewer. My eyes looked piercingly from the center of the canvas, bold and challenging, while my face was shadowed in red, my fingers were gnarled and pink. It was an in-your-face painting, the message loud and clear: I'm blind but I'm still me; I'm blind but I still understand. Instead of just two eyes I now have ten. I needed to let everyone know that my sense of touch allowed me to visualize the world as well as a sighted person did. Maybe better. I was angry and afraid.

I signed my work with two crossed-out circles, representing eyes that couldn't see. You don't need eyesight to get along in the world, I wanted to scream. Perception and understanding are not limited to eyesight. This had been my biggest problem since losing my sight. People around me would say, "This baby is cute," or "This flower is beautiful," and then they would add, "if only you could see it." They didn't understand that I was seeing with my hands. I would touch something, form an image and so see. I was proud of my new vision, but it was dismissed by everyone around me.

The painting *Ten Eyes* made me feel incredibly good. Maybe it wasn't the best painting in the world, but for me I had achieved something. I had made a point about how I felt. And I had created something new. Having never painted in my life before, it wasn't a shadow of something I had once done better. It was such an amazing feeling to think that maybe my life didn't have to be less than it should have been, less than I'd wanted, than other people had wanted. For the first time I didn't feel as if I'd been robbed of everything. For the first time since going blind I had gained something.

There was nothing about the painting that shouted out that I was blind. Instead it was the first effort of a beginning artist. It was starting to make real sense to me that nothing had changed for

me except the visual wiring in my brain. I didn't have to be pitied or viewed as harmed or spoiled. Maybe if I could really believe that, my friends and family would, too. There was no reason that the severing of the connection between my eyes and my brain should sever me from meaningful human contact.

I started to live in a world of red, white, and black, and all the possible variations in between, including grays, off-whites, and pinks. But for the most part, in my first paintings I stuck with those three colors that had meant so much to me back in the art store, especially red. It matched what I felt inside and drew me like a battle cry. It was raw and unsubtle and I liked it for that. This was me making my comeback into the world, and I wasn't going to do it quietly.

My next painting, *Red Stockings,* showed a ghoulish face leering and pale hands groping a pair of female legs clad in bloodred stockings. It was a primal painting, depicting fear and isolation, a desperate need for human contact, for love in whatever form. It was a sad and bitter painting crying out for help.

I kept my work hidden away in the back bedroom or in the den covered with a cloth when friends came over, dismissing it with a wave of my hand if people asked. "I'll show you when it's finished," I would say and then never did. It was hard for friends not to know what I was up to—my hands and hair and even Ann still were often clogged with paints—but they never inquired too deeply. They sensed that it was private and they knew better than to push. It was one of those parts of my life that they weren't involved in, like my Orientation and Mobility training, just another mysterious thing that a blind person did. For my part I didn't want to have to defend something that was quickly beginning to have very deep meaning for me. And that was, admittedly, a little odd.

Church

The Unveiling

One Friday night my parents were over for dinner. It was our weekly ritual, a good way of catching up with one another and chilling out. Sometimes they took me out to eat but this time I'd grilled burgers, making my way around my kitchen with ease, though I'd sensed my mom standing by, checking on me. At the table she passed me ketchup and mustard, putting the containers carefully in my hands instead of letting me find them. I swallowed down anger with a beer. They still hadn't adapted to my blindness. They'd known me for so long as a sighted person. "How are things at home?" I asked. I found out news about a cousin, about a neighbor, but conversation was strained. Gone were the easy days when we could talk about anything. Now there was an elephant in the room that we all edged around.

"I'm still painting," I said.

"That's good," said my dad. "It's good to keep your mind busy."

So you don't have to think about being blind. I read between the lines.

"Wonderful, it's so good that you still have a hobby," said my mom. "You were such an amazing artist before . . . when you were younger." Then she was silent, probably wondering why she had said something that sounded so heartless.

"Yes, I know," I said. "But I never painted before. It's fun."

My parents were quiet. They both sounded heavyhearted as they rustled in their seats. They would leave soon. It wasn't fair to have all these miscommunications and missteps, all well-meaning and unintended. My parents and I loved one another; we'd been through so much together, it was heartbreaking to sit together like this and not know how to say something that didn't mean something else by mistake.

"Come on," I said, suddenly feeling young and hopeful. "Why don't you take a look?"

I slipped down from my chair. It would be good to have some feedback, to find out if my drawing and painting techniques were working.

"At what?" asked my dad.

"Your paintings?" My mom sounded worried.

"Yes, come on."

"Are you sure? You said you'd show them when you were finished." My mom's voice was strained, as if she were being told she needed unpleasant surgery. My parents were still sitting in their chairs. I could sense that my dad was looking at my mom, probably bewildered by her reluctance.

"It won't take long," I said, but now I was beginning to doubt myself. Why had I offered to show them? "Only if you want to, of course," I said, my voice trailing off. Even to my own ears I sounded pathetic.

That got my mom to her feet. I led the way to the den, as if leading a funeral procession. I made my way to the far side, through the muddle of easel and paints, and wrenched off the sheet that covered my two finished paintings.

Behind me my parents were speechless. My mom gasped and then I heard her begin to cry. Something broke inside me at the same time; I just wasn't sure what it was. "I didn't think they were

that bad," I said, my voice cracking, trying desperately to joke. My mom was hugging me, her head buried in the side of my neck, and I felt like a teenage boy again, tall and awkward but still needing my mother's love.

"John, they're so good," she said. Then she broke down again. "Aren't they, Gary?"

I felt my father's hand squeeze my shoulder. "Amazing." My father was a quiet man, not given to emotional outbursts or high praise.

My heart soared. I felt like I had been away from my parents for so long, but they had been here all the time. We stood like that for a long time as the light outside the windows dimmed. The den was dark, but to me it was the brightest it had been for months.

Later I turned on the lights, aware that while it didn't make a difference to me it did for my parents. It was a simple gesture but one that showed that I still understood their world. They in turn were starting to understand mine.

That evening my mom looked at my paintings for a long time. By then my dad and I had turned on the TV to catch a football game.

"I didn't want to see them, John," she said. "I didn't want them to be bad, to have to pretend to like them. Or worse, to have to tell you the truth." She started to cry again. "I couldn't bear to see the look of disappointment and pain on your face. My heart would have broken."

Life was so complicated. I loved my mother so much at that moment for everything she had done for me, for everything she had gone through with me. I had not made her life easy. I was glad that my paintings weren't as bad as she feared.

"I didn't know, John. I didn't know that you can still see."

Lost Buddha

Life, One Brushstroke at a Time

Painting became as necessary to me as breathing. It was my obsession. There was never a day when I woke up and decided to take a day off. It had become a part of my existence. In many ways painting was my means of expressing myself. And the interesting thing was that the more I painted, the calmer I began to feel. I was channeling my anger into my art, turning it into something positive, but I was starting to understand that my anger was not replenishing itself as quickly as it was being used up.

I painted for fourteen to eighteen hours a day every day, and during my painting sessions time itself became reduced—or magnified—to a brushstroke. My life continued brushstroke by brushstroke. I focused only on the amount of paint on the tip of my brush and how to transfer that paint to the canvas to create the image that was in my mind. I was unable to think about the things I had lost from my past life, or dwell on what I could no longer do. The future became meaningless. All I could think about was the contact of brush to canvas over and over again. In many ways painting was like meditation for me, a clearing of the mind of all unnecessary thoughts. If a thought slipped into my mind and took me away from my painting, I had to throw the thought away and return to the focus of brush on canvas. It was therapy. It worked.

When I wasn't painting, my mind would stay in this state of living in the moment before shifting back to the way I used to live, with worried thoughts about the past, present, and future crowding in. But the moment-to-moment existence would last a little longer each time. For a day, maybe, and then two days. Then for longer and longer periods of time until my old ways of thinking, of worrying, were replaced by a constant sense of quiet calm. There weren't any handholds for stress and depression to grab onto anymore. For the first time in my life I felt truly hopeful.

My days of painting in the summer turned into long fall days of painting. My small corner of painting clutter in the den started to sprawl a little into the middle of the room, and I kept on painting. Evening arrived earlier each day and while my friends complained about the onset of winter, I stayed happily inside my room, painting into the night. I would take nocturnal walks still but now they were shorter, just breaks so I could clear my thoughts, breathe in some night air, and return to my canvases.

Around Christmas something happened. At first I was aware just of an absence in my life, aware that something was different, but then I realized. I caught myself laughing, really laughing for the first time in months and knew that my anger had gone. It had been replaced by a sense of calm. I realized I had turned a corner.

The painting I was working on reflected this change in spirit. Gone were the strident colors of my first angry paintings, replaced instead by pinks, browns, and oranges, all mixed from my original color trio of black, white, and red. I was painting a Buddha, the same wooden statue as in the first drawing that had given me the courage to paint. Maybe subconsciously I was looking for calm by choosing such a serene image. When I had started the painting, my mind had been filled with a sense of anger, of disconnection and isolation, and so I had painted the Buddha in a sea of mist backed by an ominous sky. The painting was titled *Lost Buddha*. But I was still

painting incredibly slowly, and perhaps the calm of the Buddha had bestowed its magic on me while I worked and helped me to find myself. By the time I finished the painting, my anger was gone, and I felt a sense of peace. I had been blind for sixteen months.

With my new sense of calm came a new sense of perception and understanding. Yes, I had lost my sense of sight, but the way I had allowed myself to lose my place in the world was my true blindness. I'd become blind to my sense of self, my self-worth. No wonder I was depressed. My whole life had become centered on my failings. I realized that if I had viewed my exploration into painting in the same way, I wouldn't even have finished my drawing of the Buddha that first night.

I needed an attitude adjustment. If only I could approach my daily life as I approached my artwork. There everything came from my painstaking learning of techniques and my refusal to entertain the notion of failure. I'd come up with new techniques in every painting I'd done as I hunted for better ways to create my maps, more efficient ways to apply the paint. I tried method after method, eager to improve my work and time and time again I failed. I made mistakes. But the funny thing was with the painting I didn't view them as mistakes or failings but as a learning experience, a way not to try that method again but to seek out a different way instead. They became places I'd visited on the way to a final destination.

I wasn't like this with my blindness. I was hard on myself. Every time I stumbled with my cane or hit my head on something I hadn't seen was a reminder of my failure as a person. More evidence for just how useless I'd become. If I tried a new route to a coffee shop and it didn't work out, I would let my failure ruin my whole day, and I would extrapolate from one such incident and worry that my whole life going forward would be one failure after another. It was a hard way to live.

Each time I finished a painting I was struck by the fact that all the mistakes I'd made along the way weren't visible at all. They no longer mattered in a negative way. They were part of a process that had helped me to learn and move forward and finish the painting. I wanted to live my life like that. I made it my goal to ignore the constant little mistakes I made every day and to focus instead on my successes. It sounds easy to say that, and it was. It was much harder to live like that. As humans we judge ourselves and others all the time. It's who we are. We live in a world where things are good or bad, black or white, right or wrong, where there is very little room for or appreciation of the gray areas. But I taught myself not to judge. Not to constantly be my own most negative critic . . . in my painting and my own life. Whenever I launched in with an opinion, a reaction, a criticism to something I had done, I stopped myself. It was amazing to note how many of my thoughts about myself were negative.

I tried hard to think of my successes and failures as guides to keep me on the right path, moving forward, to wherever I wanted to go in life. If I got knocked down in a crowd I didn't let myself feel anger or frustration. I picked myself up and tried again, with a different approach. If I got lost on the way to a coffee shop, then I had found one more way of not getting there. I remembered something I'd read as a child about Chuck Norris. He once said it never bothered him when he was punched or kicked by an opponent. He just made sure that the opponent didn't hit him the same way twice. I made sure to learn from my mistakes and reframe negatives into positives.

My art became my life and my life became my art. The two were so intertwined that I couldn't imagine one without the other. Painting had become my lifeline back to myself, my family, and my friends. I could no sooner decide to stop painting for a day than I could choose to not breathe. Or a sighted person could choose not to see.

My four-by-four-foot painting space in my den soon spilled into the entire room, so I moved my studio into the back bedroom. Then my artwork spread into the kitchen, the living room, and my bedroom. In the end I pushed my bed into a gigantic walk-in closet and converted the two bedrooms into art studios. It was perfect. If I was working in what used to be my bedroom, I'd sleep in the bed in the closet. If I was working in the other studio, I'd collapse in exhaustion on the couch. And if I was back in the den painting, then there was a couch there to crawl onto and sleep. I would paint until physical exhaustion hit and I fell asleep on my feet. It was important to have beds close by.

With my paintings accumulating around my apartment, it was impossible for my friends not to see them. I didn't introduce my paintings to them with a formal viewing like I did with my parents. I didn't want to go through the anxiety and emotion of that again. In some ways I was still nervous about my friends' reactions, not to my paintings themselves, but to the notion of my painting. I could still understand that they would find it odd, maybe hard to talk about. However, I needn't have worried. The paintings gave them something concrete to ask me about. They wanted to know about techniques, what I was going to work on next, and almost immediately their perspective of me seemed to change. Just like my mom they figured out pretty quickly that I could still see, just that I wasn't using my eyes to do so. It was a huge step forward for them and for me.

All of a sudden I was no longer the blind guy. I was still blind of course, but I no longer inhabited a world that my friends didn't understand. I was more like them than they had understood, than they had ever imagined. They didn't know what it was like to be blind—any more than I had known what it was like to be blind before I experienced it firsthand—and now they had some idea of what I could perceive. And, of course, if I could still see I could still understand. I had made it back to the fold.

Morning Birdsong

Painting toward Dawn

The sound of laughter pealed out of the den, and then the hum of voices started up again. I wondered what everyone had found so funny, thought I might go and find out but decided against it. First I wanted to finish up the self-portrait I was working on. I gave myself back to my painting, losing myself in the process, the chatter of my friends in the other room left far behind.

It was like this most nights now. The usual crew—Brooke, Levi, Dee Dee—would come over and we'd chill for an hour, just talking about classes or whatever, then we'd go to Cool Beans or Lucky Lou's or one of the other bars nearby and grab something to eat. Like old times. Except I'd have my white stick with me. It wasn't awkward anymore though. My friends weren't amazed that I could walk along the street without help or that I could cross over University Drive without being run over. Or at least they didn't show it. It was possible that they could have just grown used to it but I didn't think so. I was convinced that seeing me painting and seeing the paintings that I could produce had changed their perceptions of blindness entirely, both their perceptions of what it means to see and their perceptions of me. The more I painted, the less I was defined by my lack of sight. My blindness became just another characteristic, like the color of my hair.

Some nights my friends met at my apartment but ended up going off to eat without me so that I could get some painting done. I loved that. Knowing that I could go out with my friends if I wanted but also having a sense of purpose waiting for me in my art studio. It felt like I'd found a place for myself, one that combined some of the familiarity of my old life with the artistic endeavors of my new life. Before I started to paint I had stayed home sometimes because I couldn't face going out with my friends. Everything was too complicated and depressing and I felt lonely even when I was with my friends. Staying home had been depressing and lonely, too. It was amazing to me how much painting was changing my life for the better.

Just as tonight, my friends often came back to my house after the bars closed. I'd put down my paintbrush, and we'd gather in the den. They'd be loud and happy after a few beers, and I'd be glad to hang out with them, soaking up their energy, leaving my paintings behind. We'd sit and talk for a while, and then back I'd go to my studio, my need to paint overwhelming me. Sometimes I'd hear someone ask, "Where's John?" but mostly no one did. They knew by now that I'd returned to my painting.

The laughter beckoned again. And the smell of something delicious on the grill, burgers or steak, wafted over to me making my stomach growl, a reminder that I'd missed dinner, and that maybe I'd done enough painting for tonight. Part of me itched to stay at work, to fine tune the last details of the portrait until I could lay down the brushes with the satisfactory feel of completion. But I ignored it and started to pack up. I had reached a good stopping point and needed a social fix right now. Besides I didn't have to worry about my subject going away—that was the great thing about self-portraits—I was always available. And if I felt like a change of material, there was always Ann.

I headed into the living room, felt the warmth of friendship envelop me, and relaxed. I felt the intense concentration of painting slide away, like a cloak I could take off, and I knew I could stay with my friends for a while. Some evenings the call of the studio was too great and then I'd hop back and forth. But for now I was calm. Brooke handed me a burger, and I ate in happy silence, conversation flowing around me, about me, about their evening, my painting, and I gave myself over to it. When my friends left later, drifting to the door and heading for home, I would go back to my studio, and then I would be alone, painting toward dawn.

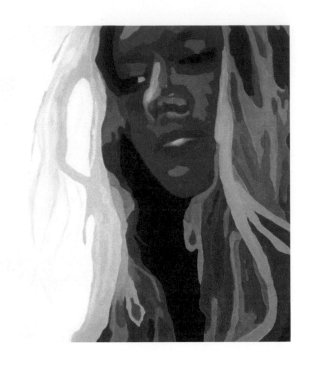

Muse

A Positive Energy

The plan was to go to the party for just a few minutes and head back home to my studio. I was working on a painting I really hoped to finish. I hadn't wanted to go at all but Brooke was convinced that I would like a girl there, and so I allowed myself to be persuaded. I wasn't sure if I was ready for dating but Brooke was persistent. "Just five minutes," I said. "Fine," said Brooke, "and if you don't like it I'll drive you home."

The party was at a girl called Jacqi's house, and we could hear the music pumping before we pulled up outside. I knew this part of town, not so far from where I lived, and I pictured the beautiful old wooden houses in my mind. Climbing the stairs to the second floor, the music mixed with voices and laughter. Everyone sounded so young and carefree. I shook my head a little and breathed in deeply. Sometimes when I'd been home all day, lost in a painting, it was a shock to go out into the world of people, a world of buzzing energy that turned into a flurry and flutter of images in my mind, and I'd need a few moments of adjustment. It was like this now. Maybe Brooke knew because she put her hand on my arm, reassuring me, as she opened a door with her other hand. A blast of sound hit me: music, voices, laughter. The room was small and crowded, the sounds funneling together, producing

color and energy in my mind. I stood still, assessing the scene, my heart drumming a nervous rhythm. I was always slightly nervous around new people, sure that my blindness would be an issue. Sometimes I'd go into a room with my friends and hear everyone else get a greeting except me. I was used to being invisible. We stepped into the room and I stood next to Brooke, wondering how quickly I could have a drink and leave. The painting in my studio flitted into my mind and I felt that pulling sensation in my stomach, my need to be back there, painting. I took a deep breath.

"John, this is Laura," said Brooke, squeezing my arm tighter than she needed so I would know that this was the girl she thought I would like.

"Hi," said Laura. She sounded nice.

I smiled in her direction. "Good to meet you."

"We're out of glasses," she said, "so I hope you don't mind your wine in this." She handed me a glass of some kind but with a handle and a small lip. I could feel writing on it, markings going up both sides.

"A measuring cup," I said.

"Yes, you're lucky, some people are drinking out of vases. There are always more people than glasses when Jacqi has a party." I could believe it. The small living room seemed to be getting fuller by the second. "People will end up sitting on the roof deck soon."

To my right someone laughed, an infectious, effervescent laugh that set off a ripple of laughter from a whole group of people. Just listening to it, I relaxed. It was like therapy. I drank my wine, took in the sound of Laura telling me all about the newspaper, about deadlines and articles and print runs, and let the image of my canvas back at my studio drift further and further away. I liked Laura well enough and maybe on another night I would have liked her more, but as I listened to her voice part of my mind was searching for that laughter. I wanted to hear it again. I wanted

to meet the person behind it, a person who could clearly induce relaxation and well-being by her laughter alone.

I didn't have to wait long. Brooke appeared at my side again with another introduction. "This is Jacqi."

"Our lovely host," I said, somewhat lamely, but then she laughed. Immediately I felt like a million dollars, as if I'd said the wittiest thing on Earth. I laughed, too. It felt good as it still wasn't something I did as often as I should. I forgot about the crush of people around me, about Laura telling me about newspaper editorials, about the music pounding in my head, and listened only to the rise and fall of Jacqi's laughter and my accompanying rusty chuckle. I don't know how long I stood there like that but it was long enough to know that I desperately wanted to be Jacqi's friend. That life had to be better if you hung out with someone like that, that maybe some of her sparkle would rub off on me. She made me realize how serious I had been recently, how I had let myself harden with anxiety and fear. Life had become a constant struggle for me, and I was scared of letting down my guard.

"You paint, right?" asked Jacqi. I nodded and stopped laughing. She knew things about me. That couldn't be good. I wanted to talk to Brooke alone, to find out what she had told her. I cast around, listening out for her voice.

"Me too," continued Jacqi. "I'll show you my studio."

Immediately my emotions flip-flopped the other way. I stopped worrying about what she might know about me and, amazed by what she had just said, by the point that we shared something in common, I followed her through the crowd into another room. Her studio. I didn't know anyone who had a studio. Other than myself, of course. Obviously we were destined to be soul mates.

"I haven't been painting long," she said. "An artist friend from New York stayed with me for a few months and I got inspired."

She laughed. That laugh. "Take a look around. I've got some canvases hanging up. I just staple them to the wall, prime them, and paint right on them like that."

That was new to me. I thought of all my carefully stretched canvases at home.

"You can paint like that?" I asked.

"Sure, why not?" She laughed. "What do I have to lose?"

She was so unlike me. Easygoing, open, unworried. Had I ever been like that? Before the blindness? Before the epilepsy? I couldn't remember. I just knew I wanted some of that spontaneity, that fun in my life. I hadn't even known it was missing until now.

I walked across the room to the far wall, my fingers brushing the parallel wall. It felt shiny, slightly rumpled, not like paint or wallpaper, and I guessed it was a plastic drop cloth. So Jacqi had taped or stapled drop cloths to the walls and then put the canvases on top. That was smart. My fingers caught the edge of a canvas; I knew immediately. It was a sensation that was engrained in my brain from all those hours I'd spent in front of a canvas, making my maps, figuring out where to draw my raised lines. And in my mind an image flickered of a canvas, but more than that. It was a warm image, one of promise, of excitement. Of possibility. It was a multilayered image for me: the physicality of the actual canvas combined with the emotions it evoked. Touching was more than just seeing for me.

"May I?" I turned back to where Jacqi was standing in the center of the room.

"Sure," she said. I liked that I didn't have to explain myself. She knew straightaway that I would need to touch her painting to see it.

It's interesting because touching someone else's paintings is a very personal experience. People put so much of themselves into their artwork, and it comes through in the ways the paint has been

applied. A short stabby brushstroke comes from a very different place inside the artist than a long fluid stroke. You feel an emotional connection. I had the good fortune to touch a Van Gogh once, to touch the paint that he had placed on the canvas and feel the turmoil of emotion in his brushstrokes. I felt a Rembrandt too, and the difference was amazing. The brushstrokes were so fine, so carefully and serenely applied, that I felt the little bristles left behind in the paint. Not so with Van Gogh. The bristles from his brush would have been buried under the thick, passionate dabs of oil.

It was the same with Jacqi's art. At my first tentative touch, I suddenly felt like I'd known her for years, like we'd stayed up all night talking over our strange kitchen containers of wine and baring our souls to each other. Her paintings sang with exuberance, with texture, as if she'd poured positive energy onto canvas.

I must have turned questioningly to her because she explained, "I just use latex house paint and mix things into it."

"Like sand," I said. I could feel it swirling under my fingertips in the painting I was looking at.

"And drying agent."

"That's cool," I said. It was. I hadn't thought about adding anything to my paints before. I loved how she had come up with the idea of creating texture, of how her paintings weren't just about images, or color, or how they looked. They were about how they felt, too. They seemed raw and primordial to me, archetypal, but somehow they danced with joy and lightness of heart, too. Maybe that came through Jacqi's artistic intent. I sensed that she used art to experiment, to express her feelings, to have fun. It was eye-opening to me. Painting for me had been so serious, a constant struggle with depression and disability, a way to stay sane. Jacqi painted the way she laughed.

"I like them," I said.

"Thanks." She poured me some more wine. I got the impression that it didn't matter to her what people thought of her paintings, that she did them for herself, for the process rather than the end point. I envied her that freedom. She didn't have to paint to prove herself to the world. I desperately wanted her to come to my studio and see my paintings. And to love them.

"My real artistic passion is photography."

I didn't feel proud of myself for it but my heart sank. I felt as if for a moment we had shared something profound and already it had gone. In many ways photography seemed far away from me, like my old experience of seeing Saturn. I couldn't touch photographs and have an image spring to mind. There would always be a barrier; someone explaining the image to me. I took another swig of wine from my measuring cup.

"I use this room as my darkroom, too. I have black plastic stapled above the windows and over the door so I can make it dark whenever I want." She laughed again. Hope came back into my world. "It looks like a mess but it does the trick." I laughed too. I loved the fact that she stapled black plastic and raw canvas onto her walls without worrying about it. Who was this girl and where had she come from?

The door to the studio opened and someone came in.

"Nate!" Beside me, Jacqi got up.

"Thought you'd be in here if you weren't on the roof."

Jacqi introduced Nate to me and we said, "Hey," but the conversation soon turned to Jacqi's photography and I felt lost. Nate was a photographer with the *Dallas Morning News* and Jacqi had some questions for him. She pulled up an image on something she called an enlarger, and they talked in detail about light levels, aperture, timing, and other things until it all floated over my head and merged with the music from the living room. For a while I imagined Jacqi making the room dark, pulling down the sheets at

the windows and door, and creating her own private darkness. I imagined that this made us closer, that she knew a little about a world without light. But then I became aware that Nate and Jacqi were standing very close to each other and I wondered if they were more than friends. I slipped out of the studio back into the living room. Maybe I should go home now.

"John, there you are." It was Brooke. "Where were you?" She giggled. "With Laura?"

"No," I protested. The very idea seemed alien to me. "Jacqi was showing me her paintings. In her studio."

"Oh," said Brooke. She sounded disappointed, bored even. She'd tried to set me up with someone and I'd just talked about paintings instead. I imagined her rolling her eyes and wondering why she bothered.

"What does she look like?" I asked. "Jacqi, I mean."

I wasn't usually interested in looks. I would form my own image of people in my mind based on their voice, their personality, and I had already started to do this with Jacqi. But for some reason I wanted to know what she really looked like.

"Blond hair," said Brooke. "Long, blond hair and very pale blue eyes. She's wearing woodland camouflage cutoffs and a tight blue T-shirt. She looks good."

It wasn't much to go on and it wasn't really what I wanted to know. I'd wanted details like whether her eyes lit up when she laughed, whether she put her head to one side when she looked at you. Did her eyes change color as she talked?

I nodded seriously, absorbing the information.

"You like her?"

"She's interesting."

I didn't want to tell Brooke about the incredible connection I felt around Jacqi, that I felt happier around her even though I'd met her only two hours earlier. Better to let Brooke think I liked

Jacqi as a fellow artist. Because it wasn't going to go anywhere.

It was almost morning and the party thinned out and somehow it was just me, Nate, and Jacqi. I couldn't help myself. I still didn't know the nature of their relationship, didn't know if they were desperate for me to leave so they could be alone, I just wanted to be around her. I hadn't felt this good in ages. I was sitting on the couch in the living room talking when I felt something jump onto my lap then leap away, fur brushing against my arm. "Was that a dog?" I asked. It was long and low, maybe a Dachshund. I'd been kind of surprised by the suddenness, the scraping of its toenails across my thighs, and I felt a little rattled, on guard, in case it jumped on me again. Jacqi laughed. If it had been someone else, I might have closed in on myself a little, thought I was being laughed at. But not with Jacqi. Her laugh made me feel better.

"That was Molly," she added, "my ferret."

"There are two of them," said Nate, "and they live in the couch. The other one's really mean."

"She's a rescue ferret," said Jacqi. "Not mean, she just wasn't loved enough."

I stood up quickly at that and laughed. Part of my brain was thinking, wow, this girl really is something else, while the other part was thinking I don't have a problem with ferrets but I don't want to be surprised again or, worse, attacked by an underloved ferret.

I said I should leave. I didn't want to but I knew I should. I didn't want to be that guest who came to a party and stayed forever. I imagined Nate saying, "The crazy ferrets attacked him and still he stayed." Brooke had left long ago, but I knew I could walk home. The apartment wasn't that far from mine and I'd find a landmark easily enough and get myself home. But Jacqi wouldn't hear of it. She offered to drive me herself.

If I had to leave her party then this was the best way to go—in her company and in her car. Sadly the ride was too short. It turned

out I lived only two blocks away. "You want to see my paintings?" I asked. I didn't want her to go. I didn't want her to return home to Nate.

I sensed her hesitate. My heart soared. But then she said, "I should go. It's late." I listened to the sound of her car engine as it pulled away into the distance and then she was gone. I was left alone in the early morning silence of my street. After a moment I let myself in to my apartment. It seemed lonely and empty. I went straight over to the painting I was working on and threw myself into it, my heart drumming with hope in my chest.

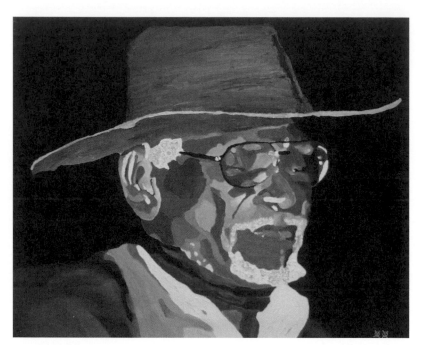

Pops Carter

Seizing Life

Whenever Brooke called me after that, my first question would be "Is Jacqi with you?" If the answer was yes, then I would drop everything I was doing and join them. It was probably pretty obvious to everyone what was going on with me, but I kept it as low-key as possible. I didn't want to ruin things so early on by telling Jacqi that she made me incredibly happy. Or worse, telling her that she made me feel more like me. Instead, we met with friends at Cool Beans for a burger and fries and talked about art. It was our first point of connection, a safe place to start a conversation that didn't involve blindness or epilepsy or feelings. I loved the fact that Jacqi didn't push these issues, didn't constantly ask how I was feeling. She was one of a growing group of friends who had met me after I'd lost my sight, and they all accepted my blindness more easily than my old friends. It made sense and I didn't blame my old friends. It was just interesting. Jacqi's mom was the director of a day school for people with mental impairments, so she had grown up around people with all kinds of disabilities. My blindness just wasn't an issue for her. So in many ways it wasn't an issue for me when I was with her.

Finally we planned our first date at Art Six, a coffee bar and art gallery on Bryan Street. It was the perfect place to meet: low-key, great coffee, and good art. I was nervous and excited, and colors

started leaping through my mind as soon as I heard her voice. She was full of a funny story that had happened at the newspaper that morning, and I sipped my coffee and listened to her voice and her laughter. One of the great things about Jacqi was that she was genuinely interested in my artwork and I could talk to her about new techniques I was trying. Now I was using every painting I did to teach myself more about technique, to develop faster and better ways for me to get the paint onto canvas. I was also trying to come up with ways to get rid of the raised lines in my paintings as they stopped the flow of paint like dams. I loved discussing my ideas with Jacqi as she had a real appreciation for what I was trying to achieve.

"What's the art like that's up on the walls?" I asked.

Looking at art was one of the things I really missed now that I was blind, but I figured that of all my friends Jacqi would be able to describe it to me best.

"It's good," she said. "Watercolors but bold not insipid. Finish your coffee and I'll show you."

I gulped down the remaining coffee and leapt to my feet and reached for my cane.

"I can guide you if you like," said Jacqi.

I very much liked her idea. It was hard to use my stick in a small place like Art Six. I placed my hand in the crook of Jacqi's arm, wishing I could hold her hand instead, but Jacqi had been around blind people before and knew the way guiding was done. We walked over to a wall of paintings and Jacqi started to describe them in detail, telling me about the size of the painting, the colors, the paints, the texture. I hung onto her every word, the paintings appearing in my mind. Then she took my hand and sketched out the visual details on my hand. At that point I stopped caring about the artwork. The intense colors in my mind were going crazy. Jacqi gave me a new way of viewing the world.

—·—

My apartment on Hickory Street was often home to a party, given its central location and the fact that everyone knew I'd be awake half the night painting. Now Jacqi became part of the after-bar crowd, showing up with Brooke or her friend Robin, ready to mix up a few martinis. Robin and Jacqi were like brother and sister. They worked together at the production office of the university newspaper. He would say something that would make her laugh and she would punch him in the arm. Then he would punch her in the arm and she would punch him back, really hard. They burned up a lot of energy together and were fun to have around. It may have been Robin who started the martini phase. We all got hooked on it, trying out vodka martinis, shaken not stirred, Gibsons, and lemon and apple martinis. We got hooked on dancing, too. My after-bar sessions before had been a group of friends just gathering to chat and hang out, maybe watch some TV, with me flitting back and forth from my studio. But Jacqi and her friends were dancers. We'd crank up the music and dance.

One night we got a fog machine for a party and churned out fog so thick that you could taste it with every breath. It didn't make much of a difference for me, but I could hear my friends stumbling around in the mist, bumping into each other and things. We called it a blind party. I guess I'd moved far enough along in my blindness if we were able to make jokes about it. I decided the red lights needed to go during a fog party. I imagined how my apartment must seem to my neighbors with mist swirling out the door, music blaring, and red lights strobing around. Maybe like a scene from Dante's *Inferno*. To soften the appearance of hell, I chose white Christmas lights and hung them around my apartment, where they twinkled prettily.

Even after the party I didn't put the red lights back. They were from a different stage in my life, like the red paint I had used constantly. Now I liked the sparkly lights strung across the ceilings in

each room. They had a touch of magic about them, of fairy tale and promise. They lit up a room enough for my friends and they didn't hurt my eyes so they were here to stay.

Those sparkly lights seemed to mirror my newfound optimism. Whenever we danced they twinkled in my mind, mixing with the colors of the music. We danced to all kinds of music on different nights but it was dancing slowly with Jacqi to Frankie Valli's "Oh, What a Night" that made me happiest.

—·—

My first dates with Jacqi were filled with music and bright color. Music as we often went out in Denton to catch whoever was playing, and color because the strong emotions I felt around her were always defined in my mind as color. Emotive color. My feelings for Jacqi mixed with the colors I saw in the music that was playing.

Sometimes we'd go from bar to bar listening to a band and having a drink and then moving on to another place. We got around on Jacqi's motorbike. It reminded me of the roller coasters at Six Flags and of my nights there learning to navigate with my stick.

One night we went to a biker bar to meet Pops Carter, a Texas blues legend. He'd played with just about every great blues musician who had ever lived. He lived in Denton and I had seen him around town, and I'd had the idea to paint his portrait. I'd painted portraits of my friends, myself, our dogs—anyone who happened to be around my studio and didn't mind me touching his or her face. But Pops was my first official portrait.

At the bar we saw him and settled in, listened to his stories, and drank with him. He was a great guy, always on the lookout for the next party. He must have been in his eighties and he had a girlfriend who seemed fifty years younger with strange vibes floating off her.

I felt Pops' face for the portrait and he laughed about it because it can be an intimate process having someone touching you with such attention. It didn't take long before I had every aspect captured in my mind, ready to call upon later when I was ready to paint the portrait. We stayed for a while at the bar before heading out into the night. We jumped onto Jacqi's bike and she roared off through the quiet streets back to the other side of town. I clung onto her, my face in her jacket, feeling the exhilaration of the ride. It was only when we swerved in front of a car near Fry Street, so close to it that I could have put out my foot to touch the bumper, that we knew what should have been obvious. We'd had way too much to drink. The car was very close. One clip would send the bike sideways and us flying into the street. I held on tight, hoping that we would be fine, that one stupid mistake wouldn't take everything away from us. Just a short time before I'd been desperate to die. Now I was praying to live.

Luckily the car slowed down and we turned onto Fry, parked the bike, and left it there for the evening. I took Jacqi's hand, pulled her to me, and kissed her. That had been too close.

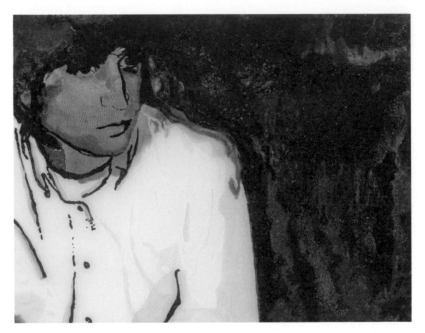

Jason

Portraits through Touch

The portrait of Pops Carter was the first painting I sold. The owner of the Texas Jive bar and restaurant bought it for $650. He was a big fan of Pops and when he first saw the painting he loved the way it captured the musician. Then he found out that I had painted it by touching Pops' face. He found that amazing. Pops loved the painting too and hung a computer printout of it in his living room next to a signed photograph of B. B. King.

Picasso said, "Painting is a blind man's profession. He paints not what he sees, but what he feels, what he tells himself about what he has seen."

After I painted Pops' portrait, I was asked many times how I could have created it if I couldn't see. For me everything comes down to ways of seeing and how much seeing is really done with our eyes. The reality is our brains interpret signals sent to us by our eyes, but in my case that doesn't work. Luckily there are other ways for the brain to receive information. My brain receives messages from other places, from my senses, and especially through my sense of touch. In essence, I see with my hands. To paint Pops and the portraits of my friends and Ann, my dog, I used something called haptic visualization. For me it was a combination of the skills I was taught during Orientation and Mobility classes

and my love of the visual arts. The blind are given very basic training in using their sense of touch: how to trail a wall, how to interpret different sensations through the cane, how to be spatially aware. These are great and help with visualization in terms of mobility, but they do not really help with being able to touch and reproduce a face. Instead, I approached the problem from an artist's viewpoint as artists deconstruct an image and then put it back together all the time.

Haptic visualization, the way I use it, is a process of breaking into small parts the object you want to visualize. In this way you can gather careful detail that relates directly to every other part. Almost like building a map. To visualize a face, I break it up into its various parts, such as overall shape, hairline, nose, eyes, eyebrows, mouth, chin, ears, jaw, and neck. When I visualize an ear, it helps to divide it into three different areas, the top, middle, and bottom or the helix, antihelix, and lobule. Next I feel each small part until it is crystal clear in my mind, and then I feel the whole until it all gels together perfectly. This takes a little time at first, but with practice one's hands start doing the work without having to think about it.

It is important to be able to compare the small parts and to relate them to each other and to the whole so they are not just floating out in space. If they are connected to each other in very tangible ways, putting the face together later on canvas is merely a process of going through each step again.

I was defining this method of visualization all the time. From the time I had touched the Buddha or the TV remote and seen its image in my mind, I had been sharpening my mind until it was a very sensitive tool. Through my intense focus on painting, I further refined my technique, forcing a connection between the sensors in my fingertips and the visual parts of my

brain. I'd always been such a visual person. I think when I began to relate images in my mind to objects I'd touched, I seized on this knowledge as fiercely as someone in the desert would grab a glass of water. For me haptic visualization became a lifeline.

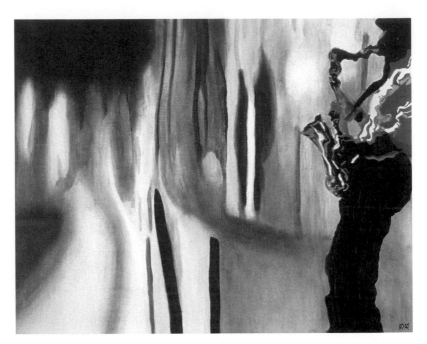

Busking

Art Connection

I did not appear at the opening of my first official show. I wanted it that way. I didn't want people to know that I was blind and to see my paintings as those painted by a blind man. It wasn't that I was embarrassed by my blindness—instead, I just didn't want it to compete with the art.

Jacqi and I arrived at Art Six early, bought coffee, and settled in at one of the soft couches. I was excited. This would be my first real art show. I had been painting for a little more than two years. It's true that Jacqi and I had entered a painting in the Fort Worth Bicentennial show, but that was just for fun. There had been art submitted by thousands of people and prizes given out that neither one of us had won. It had been a lark. This seemed more serious than that. The coffee shop Art Six was renowned for the high-quality work it displayed on its walls, and now my work was up there, my paintings of musicians and friends and self-portraits, about to be scrutinized by the general public. I wasn't scared of criticism. In fact, I was looking forward to it. I was scared of people looking at my paintings and saying nothing at all. My art was so personal, so raw in many ways that it would have seemed like a waste of time, like I'd been barking up the wrong tree if people didn't connect to it, to me in some way.

My main reason for agreeing to the show in the first place was because I wanted to meet other artists. Art was my obsession and it would be nice to meet other like-minded people. Maybe not people as obsessed as I was, but people who painted and understood that itch inside that wouldn't be eased until you were standing in front of a canvas, brush in your hand.

Now that my show was officially open, Jacqi and I sat incognito on the couch near the paintings and listened. Only my friends and family had seen my work before and in some ways they didn't count. They loved me and cared about my feelings, and so they probably gave me overly positive feedback. They also knew that I was blind. It was exciting that there were people looking at my work right now who not only didn't know me but also had no idea that I was blind. I grinned at Jacqi. I felt like a spy.

A voice nearby said, "I like this one. Is it oil paints? It's so bright. Look at that texture."

"They're looking at the portrait of Ann," whispered Jacqi.

"I wonder who the artist is?" said a woman.

The couple moved away. I wished they hadn't. I felt a strong connection to them, as if when they were looking at my work they were meeting me. It was a strange feeling.

People passed by our table, looking at my artwork, for the next hour and I heard a lot of good things, a lot of praise. Total strangers seemed to understand my images, the emotions in my work, what was going through my head while I was painting. I had thought I would sit there and eavesdrop on people's conversations but in some ways it was as if I was eavesdropping on people who were eavesdropping on me. I knew I had put a lot of myself into my work, but I hadn't realized it would be so easily accessible to others.

"They really speak to you," said a young woman to a friend.

"Yes, it's like it's not just about the image. It's like the artist is wanting to set up a dialogue with you."

I almost joined in the conversation with them, even turned my head until I felt Jacqi's light kick on my shin. She laughed and I turned back to her.

"It's so true," I said. "My painting is my way of connection. You know that. I've been trying to communicate with people through my art all this time. And do you see, now that people are seeing my art, reacting to it and talking about it, they're communicating back. It's a two-way thing."

I was so excited. It was more than I could have hoped for. Even if someone hated my work, he or she was still engaging with me. I wasn't invisible. I wasn't shouting in the dark.

Toward the end of the opening of my show, I eased myself out of the couch, took hold of my cane and tapped my way toward the wall where my final painting hung. I lounged casually, a friendly expression on my face.

An older woman stopped near me. I guessed she was looking at the painting. I sensed her turn to me and felt a soft touch on my shoulder, "What a shame you can't enjoy these paintings. They've really touched me." I smiled. I'd had people say this sort of thing to me before. "I wonder who the artist is," she added.

"I am," I said.

"You?" She sounded as if she were about to laugh but then she caught herself. "You painted these pictures?"

"Yes, I sure did, ma'am. My name's John Bramblitt. I'm glad they moved you."

"But you're blind?" she said, questioning me. "You must have some vision still."

"I do," I said. "But not the kind you're thinking of. I see and paint through touch."

"Extraordinary," she said. Then she was gone. I would learn that after telling someone that I was the artist, that I was blind, he or she would immediately go back and look at the paintings again. This was why I didn't want to tell people up front. Knowing that I was blind blinkered people. But it was strange. It also opened them up. I could hear the questions, the breaking down of misconceptions in their voices when they talked to me. There was a constant, "But how?" It was outside their realm of experience and their realm of understanding, but now they had seen it with their own eyes so it had to be true. So little by little it would filter into their consciousness that if a blind person could paint then their perceptions about how we see were all wrong. This was the kind of reaction I was hoping for—a visceral reaction to my painting and the colors, images, and emotions I had put down on canvas, but also a reaction, a redefining of their own understanding of what it means to view the world. As an artist I was thrilled to have opened a dialogue, to have reached people, and to change them a little.

I was probably one of the few artists to do a closing instead of an opening. The woman I'd spoken with lost no time in telling others that the artist was blind, that he was standing over in the corner with a cane. I sensed people looking at me. I waved. Jacqi slipped her arm through mine, supportive and protective, and maybe proud, too. She kissed the side of my neck. "I think you're quite a hit," she said, and laughed. In that moment I realized how my life had moved forward so far in the past three years. If back on the day I lost my vision someone had told me that I would have my own art show in three years time and that I would be accompanied there by my beautiful girlfriend, I wouldn't have believed them. That kind of thing didn't happen in that new world I was entering where everything was a mere shadow of what it could once have been.

I could hear people returning to the other side of the coffee shop, looking at my paintings again, talking to each other. I was part of something. At the center of it even.

People came up to me. They wanted to shake my hand, to say congratulations. A young woman said, "My uncle's blind. I can't wait to tell him about you."

Two women with gentle voices stopped in front of me. "I'm so impressed by what you've achieved," said one. "We're both teachers in elementary schools in Dallas. I wonder if you'd be interested in talking to the children. It would be so inspirational to them."

"Sure," I said. I'd never thought about it before but I liked the idea of standing in a classroom full of kids. Maybe I'd get them to paint somehow. Blindfolded. "That would be great," I said. "What do you think, Jacqi?"

"I think that would be good." I could tell she was smiling.

A man asked me, "How did you manage?" I started to explain about my painting techniques, the raised lines, the fabric paint, and the mental maps. Partway through he stopped me. "I didn't mean that, man. I meant, how did you manage to stay so calm? To create something? To move forward? How did you not go crazy or kill yourself?"

I was silent for a moment. Choked up. I was remembering that bad place where I'd lived for a year. In front of me the man was fighting down his own emotions. "I did go crazy," I said. "This was the only way I knew to get back."

Then he clapped me on the shoulder abruptly. "Good for you, man, good for you."

Before I could say anything he was gone. I had touched a raw nerve in him somehow. I wished I knew what was happening in his life. Or had happened. I wanted to help.

"He was crying," said Jacqi. Her voice trembled. "But good crying," I think. "Like you'd made him remember, or you'd inspired him."

This much I had not expected. I had gone into this endeavor looking to meet fellow artists. Instead I'd somehow connected on a deeply emotional level. People had responded to me as an artist. As a blind man. But also as someone who had something to teach to others, a message to share. It made me think.

Over the next few weeks I thought about this a lot more. Stories about my art show ran in local newspapers and were picked up by other newspapers. I became a celebrity of sorts. It was hard to fathom. Then the emails started to come in. And phone calls. My art was out in the world and people wanted to connect to me. When I looked at the cycle that had caused this, it made perfect sense, and it was even exactly what I had hoped for. When I lost my sight I lost my connection with my old world and the people in it. I started to paint to find myself again. Once I had found myself, I could find my place in this new world and reconnect with my friends and family. My artwork showed what I could see, but it was also my voice. That's where I had stood before the art show. On familiar ground. But now my artwork—and my voice—had gone one step further. Like ripples on a pond with their concentric circles, I had reached beyond my own community into a wider world. Strangers had seen my work and connected with me and then told other strangers. My art had touched a chord within, and they wanted to reach out from their lives—perhaps from their own disconnection and darkness—and connect with me. I felt like I belonged.

I received emails from around the world written in foreign languages and broken English and they mostly said the same thing: that what I was doing was amazing. That the fact that a blind person could paint had changed their ideas about perception, about what is possible, and about hope. It felt fantastic to connect with all these different people after all that time that I had spent locked inside my own mind. But something bothered me.

This wasn't quite the message I'd wanted to send. People thought I was unique. I wasn't. Ever since I was a little boy, I had seen others with worse illnesses and disabilities than mine. I knew that having epilepsy and being blind did not make me unique. Even learning how to paint did not make me unique. I had just learned how to adapt to being blind, how to use adaptations to paint. Anybody could do the same. That was the message I wanted people to know. I just needed to figure out a way to make that happen.

That's when I received a phone call from a facilitator at ArtBreak in Shreveport, Louisiana. They had heard about my painting from one of the news stories that came from doing the Art Six show and wondered if I could show some of my work at their weeklong, town-wide celebration of art. I could do something even better, I told them. I could put on a series of art workshops so that kids could try out my adapted painting techniques. They would paint within raised lines. They would wear a blindfold. They would experience what it is like to be blind. I couldn't wait to get there.

Turtle and Fish

My First Workshop

"I didn't know that blind people can paint," said a little voice near my elbow.

"You know what," I said, "I didn't know either until I tried."

That was one of the great things about kids. If they saw something that didn't fit with their view of the world, they presumed they hadn't learned about it yet. They took in new information and adapted to it.

"There's a crazy blind guy who lives across the street from us and he sits on his porch the whole time, real still, humming some old tune. But if you try to sneak past his house he sees you and calls out your name. He's pretending to be blind the whole time."

"Yeah, blind people are scary," added another voice.

"Except you." It was the same little voice near my elbow.

"Probably the man on the porch can hear your footsteps," I said. "Different people walk differently and he can probably tell who's walking by just like that," I said.

"Really? So you don't think he's a fake."

I laughed. Kids were so honest. "No, I don't think he's faking. But that's a question I get asked a lot by people, by kids and grown-ups. If they see me crossing a street with my cane and my dark glasses, they ask if I'm really blind."

"You can cross streets?"

"Sure, I can. And I can tell who's who here because your voices are different. And if I touched your faces I would get a picture in my mind of what you look like and I could paint your portraits."

"That's cool."

"Yup," I said. "Now let's get you all set up so you can have some fun painting."

For one entire week the town of Shreveport immersed itself in art. Every single school child participated in some form of artistic activity from dancing to painting to music, and the convention center filled up with noise, fun, and opportunity. It was a blast. I was on cloud nine. I walked into that convention center with Jacqi and just absorbed the atmosphere, a huge grin on my face. This was a place where I could connect and teach and learn to my heart's content.

I had been at the conference center conducting workshops since early morning and had just come back from a quick, stand-up lunch break. I was lucky that I had friends helping me out—otherwise things would have spun out of control. But at the mention of a four-day trip to Shreveport, Louisiana, a whole bunch of friends had signed up to volunteer at ArtBreak with me. Even Jacqi's mom, Marilyn, was here. It was great to have a crew from home because it was hard being in an unfamiliar place. I realized how well I knew Denton, not just the general layout of the town, but an incredibly detailed map in my mind filled with sidewalk cracks, overhanging branches, café awnings, low-lying street signs, all those things that the sighted navigate without thinking about on a daily basis but for me could turn the shortest trip to the store into a perilous undertaking. In Shreveport I knew nothing. For a moment I had that same feeling of helplessness of my early days of Orientation and Mobility training. I was aware

of how much I had to depend on my friends and I didn't like it, especially with Jacqi. I didn't want to be a burden. I focused hard on the route from the hotel to the conference center, tuned out the banter around me as I navigated my way through the glass doors to my workshop area, and scouted out the bathrooms.

But all the time, washing over my seriousness and my submerged, gnawing feeling of panic, was my excitement about being there. It was a double-edged sword. If I wanted to go out into the world with my art, I would have to travel, have to put myself into the hands of other people. But I knew my desire to be out in the world would win out. I would find ways to work out the travel part.

My workshops were set up at the very front of the conference center so they were one of the first activities people saw on arrival. I had told the organizers that my aim was to keep the kids interested through hands-on art. They were not just going to sit around and hear me talk about being blind and learning to paint. I knew I wouldn't have enjoyed that as a kid, and as an adult I didn't think I'd enjoy talking and talking to a bunch of fidgety kids. They would want to do something, so that was my plan.

A group of tables was pushed together to form a large rectangle, and we set up individual painting stations for twenty-five to thirty kids: three different paints; a piece of paper with raised lines that I had drawn; brushes; paper towels. And we were ready to go. We had kids signed up through their schools and with their families every hour on the hour for the next four days. Before the first workshop I was tingling with anticipation and nerves. Excitement and dread. This workshop would give me an idea of whether I could reach out to others in a useful, practical manner or whether my art would remain my personal endeavor. It had brought me so far—and now I desperately wanted to share.

I had a specially prepared speech good and ready but I'd forgotten about kids. The first participants surged up and took their places at the tables. A rush of energy hit me. I was surrounded by little tactile beings living in the moment, looking to experience life. Before I could speak they had questions about me: "Are you blind?" "Why do you wear sunglasses indoors?" About the project: "What's this paint for?" "Can we start?" Before I could explain what they needed to do, their fingers were in the paint and on the paper. But that was okay. Being blind had taught me to be patient, to be calm. I wouldn't put the paints out on the tables for the next group until I'd explained the project. For this group we'd work backwards. It was the experience that counted. I took a deep breath.

"Hi, I'm John," I said. "I want to show you some cool stuff today about art and about how we see. First of all, we're going to have you put on blindfolds." I started handing out cotton headscarves to teachers and parents, and Jacqi, Marilyn, and I gently tied them over the children's eyes. There was much giggling. One little girl couldn't stand still while I tied a knot in the back and the scarf slipped over her mouth. She made theatrical gagging noises, which prompted more laughter and much shushing from the adults.

I smiled, pleased with their enthusiasm. It reminded me of Jacqi's paintings in contrast to my serious artistic endeavors.

"Tell me what you can see," I asked.

"Nothing," shouted some kids.

"Really?" I asked. "Nothing at all?"

"Darkness," said someone else.

"Blackness," added another.

"I'm blind," shrieked a girl in mock terror. That got her a teacher's sharp reprimand.

"It's scary," said a boy and giggled.

"What you're seeing—call it what you like—is pretty much what it could be like to be blind. You don't see anything in front of you with your eyes. But right now, I'll tell you what I'm seeing. It's true I'm blind but I see a group of boys and girls standing at a table filled with paints and brushes and paper. They're in a big hall with a high ceiling that's packed full of people bustling around and talking and laughing. I see this because I hear things and smell things. It may not be the exact same image that you're seeing but it's what's in my head, and it's full of different colors and movement based on all the messages all my other senses pick up and send to my brain." The children were quiet now. Maybe they were thinking about what I'd said. Maybe they were trying to figure out what they might see without their eyes behind the blindfold. Or maybe they were wondering what's for lunch.

"Now, just in front of you on the table, you all have three different colors. Go ahead and touch a color, feel the paint between your fingers. Is it thick or runny, warm or cold? Just focus on how it feels."

"Ooh, it's slippery," shouted a girl, gleefully.

"Yeah, like soap in the bathtub."

"Or eels," I added. "Now remember how it feels because that color is blue. When you think you've memorized that one, wipe your fingers on a paper towel and touch another color."

"They're all so serious now," Jacqi whispered to me, smiling. "All concentrating." I could tell. The kids were quiet again, contemplative.

"How does that one feel?" I asked.

"Doughy," said a boy.

"Thick," and "Stiff," said others.

"Remember that feel. That one's red."

"Wipe your hands again and feel the third color."

"In between," said a girl. "Not thick or thin."

"Okay," I said. "That one's yellow. So now you get to paint. You'll choose your colors based on their different textures so by the way the paints feel you'll know which color you're using. This is the basis of how I started painting through touch. And there's one other thing I did. If you just start painting now with those paints it will be hard for you to know exactly where you've put them on the paper, so I made some special lines for you on the paper. Trace your fingers over the lines and then figure out where you want to paint. That's also something I do before I paint. The lines help me to know where I am on the painting— they orient me."

Before me I heard the flurry of movement, a few whispered voices. They had jumped right in, excited about the project. I couldn't have been happier. I remembered that day back in the art store when I felt the texture of the different oil paints and fireworks of optimism had exploded in my mind. I wondered if this experience would shape these children or whether it would be forgotten the moment they took off their blindfolds and were returned to the sighted world. I imagined that adults would have asked more questions about me as an artist, technical questions about mixing colors, or whether to use their fingers or the brushes. The kids had accepted within moments that I, a blind person, could paint and had greeted the project with enthusiasm.

I heard Jacqi and Marilyn's voices from different sides of the table praising the kids. Their voices were filled with emotion. Being around the kids was inspiring and it made me think that maybe there was hope for a future in which people would accept and applaud each other's differences, where people with disabilities didn't need to live apart from the mainstream. Perhaps it was

naïve of me to extrapolate such grand thoughts from one small art workshop, but I had lived in a place without hope for so long that for me these enthusiastic children were a godsend—for me and countless others who needed to be reached.

The end of the workshop came all too soon for everyone. The kids barely had time to take off their blindfolds and study their paintings before we had to herd them out and prepare for the next session.

"Put your names on your pictures," I said, "so when they're dry you can come and pick them up. I have a couple of questions for you before you leave. Do you have to be able to see to paint?"

"No!" was the resounding answer.

"Are there different ways of seeing other than with your eyes?" I asked.

"Yes!" shouted the kids.

"Like what?"

"Your fingers," yelled some.

"By feeling," said others.

"Your sense of touch."

Just three years earlier I wouldn't have found such a ready response to those questions. I would have said unequivocally that people saw the world with their eyes. Without sight you lived in the shadows of life. These were my thoughts back then and I had the proof. I was blind. I didn't want these kids to go off to their next activity, to have these tender shoots of new knowledge trampled beneath the fun of learning to dance the samba or play a xylophone or to improvise with a mime artist or one of the other myriad activities spread around the convention center. I wanted to keep them here so I could tell them more, take their hands and have them touch an object and then draw. There were so many more things I could do.

My thoughts were interrupted by Marilyn's voice and her hand on my shoulder. "That was so amazing, John. They understood so quickly. They were entranced by the touching, the painting, the whole thing. You're an advocate for the blind, John. You make everything so accessible—I don't think I understood about what the blind see until I came here today."

She gave me a hug and I thanked her. "I was just thinking I hadn't done enough."

"You planted a seed."

"What if they've forgotten by the end of the day?"

"They won't. And their teachers and parents won't."

"Are you two going to help get things cleaned up or are you just going to stand around chatting?" It was Jacqi. I'd forgotten we had another workshop arriving in the next few minutes. She came over to where Marilyn and I were standing, wrapped her arms around me and kissed me. "You were fantastic, John." These workshops were definitely a good idea.

When we ran out of space to dry the kids' paintings, Marilyn suggested we make them into a vibrant gallery, so we hung them along the edges of the outer tables, where they welcomed people like festive streamers. Within minutes we had a crowd of people looking at the brightly colored paintings, asking questions, and learning about the workshops. Our area became a mad crush of activity with kids happily squashing in at the painting stations, sharing paints and opinions.

Throughout the day kids came back to collect their now dry artwork, proudly holding it high above the crowd to show it to a parent or sibling. I heard their voices, explaining their paintings, their unrestrained excitement, and grinned as I moved from table to table. Halfway through the afternoon we started to run out of supplies, so Jacqi rushed off to find the organizer. We had four or five more workshops planned that, at the rate we were going,

would include more than two hundred more kids. I really didn't want to have to stand up and just talk. All the morning's good work and enthusiasm would be ruined if word got out that the art workshops were just some dull blind guy talking.

Luckily for all of us, Jacqi came back not with the organizer but with directions to the art supply room.

"She said we could ask for whatever we need."

That was music to my ears as an artist who'd had to be careful his whole life about the money he spent on supplies.

"She'd heard about the success of the workshops," added Jacqi as she pulled me along after her. I had a fifteen-minute break before the next enthusiastic onslaught. We grabbed lemonades from a stand and downed them in ten seconds flat, then swept up elevators and down corridors. I felt as if I were back on the roller coasters following Jacqi on a quest for pirate's treasure or dragon gold.

The supply area was a room that echoed and I saw before me table after table of all the supplies that anyone could possibly need. It was beautiful. I stood in reverential silence on the threshold imagining rows of paints and papers and brushes, rippling into the distance.. Jacqi was more pragmatic and soon had asked for more paints and paper towels, more paper and fabric paint. I would have to work on some more raised-line pictures that evening. In the meantime we had to rush back to the main hall in time for the next shift of kids.

By the end of the day, more than four hundred kids had attended the workshops and created a painting through touch. Our thirty-five-person workshops had stretched to accommodate fifty or more kids at a time, and there had been requests to add more to the lineup for the days ahead. Giddy with exhaustion. we made our way through the emptying hall toward the big front doors.

"Look, there's the guy who did the workshops," said a girl's voice.

"Yeah, mom, that's the blind artist I told you about," added a boy.

"He's not blind," the girl said firmly. "He sees with his fingers."

I felt Jacqi's hand squeeze mine. It was as if she had squeezed my heart.

Later we were sitting in a bar under the Texas Street Bridge drinking Blasters. The sound of the Red River lulled me, almost completely hiding the thrum of distant traffic crossing the bridge. My whole body ached with fatigue. I was aware of the conversation but not part of it, content to let it slip and slide around me like the water around the bridge. If someone had asked me where I was, I would have had to think about it. So many of my good friends from Denton were here with me but the bar was unfamiliar. I wouldn't have known how to get home. I felt like it was one of those moments when I'd just come out of a seizure and I didn't know where I was, when it was, or even who I was. It had that same dreamlike quality but no underlying anxiety. I felt good. That day Jacqi and I had painted with hundreds of kids. We had taught them about different ways of seeing, about perception. And now we were here with our friends, far from home, but all together. I felt very close to everyone at that point. Very happy with where my new life was taking me.

I imagined the bridge reaching over me, its vast span stretching across the river and beyond to places that I knew nothing about. I remembered when I first lost my sight how I had desperately wanted to dig a tunnel or cross a bridge to get back to the world I had once inhabited, to get back to my friends. I had done that through painting. I had crossed over the bridge, but what I had not foreseen was that the bridge would not take me back to

my old life but to a different version of my life. It had taken me home but it would also take me to other places, to a whole new life that I barely knew about yet. My friends could come with me and I would make new friends on the other side. I just had to keep going, feel my way forward, and see what was waiting for me. Art was creating a whole new life for me, one I'd never dreamed was possible, and I couldn't wait to see what was in store next.

Duke

Searching for a Guide Dog

My days in Shreveport marked a huge turning point for me. I felt as if I had undertaken a long journey and, without ever having known my destination, had finally arrived. There was a sense of a spring thaw within me after several long hard winters and it felt sweet. I began to relax and enjoy the niche that I had made for myself. No longer did I feel the need to compare myself to others, to measure myself against my friends. I had leveled the playing field for myself and now I could let go a little.

For me, letting go meant still painting obsessively, finding ways to improve my technique. It meant going to school, and suddenly it also meant more workshops and art shows, more public appearances. I worked as hard as before but now I had an air of levity about me. I had a girlfriend with a laugh that lifted me out of myself, who made me see in Technicolor, who had ferrets rushing through the couch in her apartment. I shed the cloak of self-preservation that I'd firmly wrapped around myself and started to live a little now that I had a life worth living again.

While Shreveport marked the point for me when I stopped defining myself as blind, it brought up something else, something equally important. It opened me up to great new possibilities, but it also defined my limitations. Travel was difficult for me. My stick

got me around safely in new places, but it wasn't like being back in Denton, where I knew every crack on the sidewalk and how they related to other cracks in other sidewalks. If I didn't know a place, no matter how great my cane skills were, I needed someone to help me get around. And it wasn't possible or practical for Jacqi to be my personal tour guide. She had her job at the university, her own friends, and commitments. Our relationship was solid and we often spoke of a future together, but I needed to be able to travel independently.

I decided to look into getting a guide dog and, never one to do things by halves, I spoke with every guide dog school in the country, went to meet people at a couple of them, and even interviewed guide dog users: both those who loved having guide dogs and those who had gone back to using the cane. I knew a guide dog was a huge commitment and I wanted to understand what I might be getting myself into.

Interestingly enough, in speaking with other people, I discovered that I was nervous about giving up the cane—the white stick that I had hated to use because it advertised my blindness and labeled me as different. Now it was hard for me to think about losing it. A cane always touches the ground and provides a kind of horizon or balancing point, and I worried that with a guide dog I would feel as if I was floating around in space, tethered to a leash but unclear as to my coordinates. I didn't want that unsettled feeling again now that my life felt more stable. Even thinking about it made me nauseous.

But now that I had started the thought process, it gnawed at me. Everyone I'd spoken to told me a guide dog would make travel so much easier, so much more efficient, and given the emails and phone calls I was continuing to receive, the travel portion of my life was only going to get bigger. It made sense. I decided to put my fears about losing my stick to one side and filled out

an application with Guide Dogs of Texas. I felt that they had the most innovative program in the country and spent a lot of time carefully matching dogs with potential owners. An application wouldn't bind me into taking a dog if they found one for me. I would still have a choice. This just widened my options for the future. The application process included an extensive interview so they could figure out my personality and come up with a dog who would match me, my lifestyle, and my needs. Somewhere during that interview the concept of a dog became very real to me. I began to like the idea of a guide dog, a carefully trained creature who would become my partner and constant companion. A Lab or a German shepherd traveling with me in unknown cities. It sounded like an amazing relationship. Suddenly I couldn't wait to meet my perfect match. That's when I was told that it would probably take a year before I could expect a dog, maybe longer because of my epilepsy. So I would have to hang onto my trusty cane for a little more time.

Purple Haze

Purple Cows

In some ways I began to see my workshops as a twofold mission: to teach people to experience perception in new ways and to use art as a means of expression. Art had fundamentally changed my life, and it was important to me to reach out to others who could benefit from art in the same way. I didn't want anyone to struggle with the self-loathing, the darkness, and the depression that I had just pulled through. My thought was that if art had helped me, it could work as a positive force for others, too. And if I could get people to think about what perception really means at the same time then all the better.

Now when I received calls from art galleries about putting on a show, my response was always, "Sure, as long as I can do a free workshop at the gallery." That year alone, I had seven local art shows. And each time Jacqi and I figured out new ways of presenting workshops. Most important for me was the concept of getting ideas across while keeping the workshops entertaining, light-hearted, and hands-on. I was not interested in standing up and giving a lecture or a speech. In my mind, that would be a sure-fire way to lose a potentially receptive audience. While I might give an introduction about the theme of the workshop, my talk would be more about how we were going to explore the nature of

perception and how it shaped the world around us. Then just as those thoughts were sinking in, I would take everyone off to look at sculpture and, as this was a workshop about different ways of seeing, by looking at the sculptures I meant touching them.

I had always been struck that museums and galleries had amazing, beautiful rooms filled with sculptures wrought from every kind of material—marble, granite, bronze, steel, glass—crying out to be touched but nobody was ever allowed to do so, unless they were cleaning them. Of course I understood that human sweat or oils from the skin could spoil the works of art, and fingernails and rings could scratch, but it was still a wish I had. Just as touching someone through a hug, a kiss, a pat on an arm creates an emotional response so, too, does the touching of a piece of artwork. When I was expanding upon the activities in my workshops, I asked museum curators and directors if there were ways to get around the rules and regulations about not touching the artwork, and magically, wearing pairs of white gloves, workshop participants were given special permission to touch. There's a children's museum in Philadelphia called Please Touch Museum. I've never been there but I love the sound of it.

It's always been such a thrill for me to touch the statues, to be so close to the point of the artist's creation and feel the energy and life pulsing through the sculpture. It was inspiring to feel the differences between the smooth perfection of marble and the rough details of bronze. Sometimes I found textural differences within the same piece of art that the eye just wouldn't notice. It was exciting to place my hands on a sculpture and to know that the artist had placed hands there too, had maybe left a telltale fingerprint or smudge mark buried in terra-cotta.

Perhaps my excitement was contagious but I found that both kids and adults loved the experience of touching sculptures. It was such an unusual thing to be allowed to do—and yet so natural, so

instinctive—that they embraced it with a sense of mischievous delight mixed with serious artistic intent.

With the success of looking at art through touch, I added sculpting to the workshops and continued with the sightless paintings and raised-line drawings. These especially seemed to give an awareness of the role of touch in my painting, and kids and adults alike threw themselves into projects.

The workshops constantly evolved. While some of the ideas grew from me sitting down and thinking about the best way to demonstrate or explain a certain idea about perception, some of the best activities grew from real life experiences. Like our conversations about color. Given my interest in art throughout my life, I had often thought about the place of color in the world and especially the subjective nature of color. I knew the palettes of many artists and found it curious that certain artists were attracted to certain colors and not others and that their paintings contain a very limited number of colors from the hugely expansive spectrum of available colors. When I lost my sight, color became especially subjective. If someone told me that something was blue—like Jacqi's eyes—then the color I saw for blue would be my own personal representation of blue. And even if Jacqi told me in extreme detail, citing various reference points, the exact shade of blue of her eyes it still wouldn't mean anything to me, because the way she sees color is not the way someone else sees color, and not the way I see color.

The first three paints I used—Titanium White, Ivory Black, and Cadmium Red—were colors I had already seen before I went blind and were colors that I knew. But if I tried a new color in my painting, say Alizarin Crimson, while I could feel the textural difference between that and Cadmium Red, how could I know what color it really was? For that I would have to use my memory of paint palettes and rely on a friend's description and pinpoint for

myself the color Alizarin Crimson. Now my image of it and my understanding of this new color might not be entirely accurate, but for me I now had this color that represented Alizarin Crimson in my mind. These ideas about color had made for interesting conversations with my friends, and they continued to inspire conversations and artwork at the workshops. It wasn't really something that the kids and grown-ups had thought about before. It was fun to have them paint a certain color and then listen to them react to all the variations of it around the room.

For me color and texture were intimately related. When I touched something, an image formed in my mind. If I felt a texture that I recognized from my oil paint palette, then the object became imbued with that color. A woman's smooth, creamy skin might remind me of the feel of Phthalo Blue with a hint of Titanium White, and before I could stop myself, I would see the woman turn blue in my mind.

"When I first started painting, I tried to keep things realistic," I told everybody. "But now I don't. If I see a purple cow in my mind or a woman with blue skin, then that's how they end up in my painting. I've created a new reality for myself, and it's fun to do what I want."

Depending on the age of the crowd, I might go on to add that the artist Picasso rejoiced when photography came along because he thought it would lead to a new freedom for painters. They could let photographers accurately record the world around them, while painters could paint what and how they wanted, even purple cows. Or in Picasso's case, Cubist cows.

One of the other activities I added was painting music. I would put on some great jazz and let everyone paint the rhythms as they perceived them. It became clear that music was not something that was confined to hearing. Participants were excited to

see images and colors in their mind's eye while they listened to the music blindfolded. They were learning that our senses don't always work in the ways we thought they did, that they don't always work alone, and the more open you are to experience, the more new experiences will come flooding in.

The workshops were an amazing way for me to connect with an ever-widening circle of people. After each one I was filled with such positive energy. All the participants seemed to have had fun, to have been touched by the experience, and their enthusiasm surged through me, energizing me, and soared back out to them. It was uplifting.

Woman Resin Study

Finding a Community

Standing on a podium behind a microphone in front of an audience of expectant people was not really my idea of fun. I could sense the anticipation and didn't want to let anyone down, but already my mouth was dry. I couldn't see the actual faces of the sea of people out there, but I had my own image, and in it the rows of chairs and people continued endlessly out of an undefined space without walls or ceiling. I did not like public speaking.

I had received phone calls, emails, and letters from nonprofit organizations soon after my Art Six show, and now after every workshop and art show I attended, the flow continued. From the Epilepsy Foundation, American Foundation for the Blind, Easter Seals, National Federation of the Blind, from schools and museums, art organizations, and church groups across Texas, the South, and beyond. They wanted me to come and talk, to present keynote speeches in different states. It all sounded like something I would want to do, and I did want to do it, but it also sounded terrifying. I told myself that if I had managed to deal with the difficulties of going blind, then surely I could talk to a few people, a few hundred people. At that my heart shriveled. I wasn't proud of it, but every time I thought about speaking in public I felt nauseous. So for a little while I didn't respond or I said I'd like to help

but didn't set a date and tried not to think about it. I continued with the workshops and art shows where I didn't have to stand up in front of a crowd and speak, but I didn't feel good. There were people out there who needed my help, who needed to hear that there was hope, who needed to know that someone like them had made it through the worst of it, and they could, too.

So then I said yes and avoided thinking about what I'd signed up for. Which was why I found myself now in front of a small—so the organizers had said—group of people in a big hall in Corpus Christi for a conference organized by DARS (Department of Assistive and Rehabilitative Services). On arrival, plagued with nerves and cold feet, I had asked if I could run some workshops instead and been told no, that this conference was for parents of blind children but that children themselves would not be in attendance. I had wanted to add that my workshops could be tailored to adults' needs too, but I didn't. I thought I might sound unprofessional. Or desperate.

"My name is John Bramblitt," I started. My voice sounded thin, anxious, rebounding around the room. Then I stopped, unsure of what to say next. I had prepared a text but now that I was here I wasn't sure it was what I wanted to say. Suddenly in my mind it sounded too formal, too distant. I'd been told that my audience was made up of parents, some educators, but primarily parents. I thought of my mom and dad sitting out in that audience, nervous and alone in the crowd. With a young son with epilepsy at home. Or a grown-up son with epilepsy and vision loss at college. They had been through an endless round of doctors and administrators. They were tired, frustrated, angry, and depressed. What would they want to hear?

I had been standing silent at the podium for several seconds when someone in the audience started to gently applaud. Others joined in, softly at first, and I realized that I must look as nervous

as I felt. I was being welcomed, supported by this community of people, thanked for the mere act of taking the time to show up. I felt enormously grateful and connected to them.

I started again. The words came more easily then. I spoke to the parents in that room of hope, of their kids as kids, not as kids with disabilities. They were kids with dreams who must be encouraged and supported and encouraged some more. I asked them to look around at one another in the audience and to know that they were all in this together, they were not alone in this fight, and the more they refused to allow their kids to be labeled and put down by doctors and medical establishments and education systems, the more their voices would be heard. As a group. As a community. But mainly I spoke about the need to accept that their kids had disabilities that weren't going to go away but not to accept the limits that other people tried to enforce. A life with disability didn't need to be a half life or a shadow of a life or a second-rate life. It would be a different one than the parents had expected or even wished for, but different didn't mean worse.

I told them of my preconceptions of being blind from when I was losing my sight, of how I was convinced that this new life would be one of stasis, lived in darkness—without hope or possibility or joy. And because I'd thought that way, I'd lived that way, dwelling on everything I thought I'd lost. Until the day I'd chosen to break free, take risks and live beyond my own expectations, beyond society's limitations. Let your kids be who they want to be, I said. Let them ride bikes. Let them fail, but above all let them try.

I ran over my allotted time, and when I finished I grinned from ear to ear at the applause that swept around the room. I heard chairs scraping across the floor and parents scrambling to their feet in a standing ovation. To me. To my message. I shook

hands with countless parents who thanked me for saying what I'd said. For giving them hope for their kids and for themselves.

At the very end as I was preparing to leave, a woman approached me. "I've barely slept for the past week. I've felt like such a bad mother," she said, her voice soft and unsure. "My son is nine years old. He's blind and last month I let him ride a bike because he wanted to so badly and he asked me so often. He wanted to be like his friends, and in the end I said he could." Her voice trailed off. She was close to tears. "He fell off and fractured his arm. His doctor was furious." Her last words came out in a desperate rush of guilt before she broke down and stood sobbing in front of me. I wanted to put my arms around her. I had been that boy once, railing at my limitations. I also knew how my parents had agonized over what I could and couldn't do as a kid, decisions they shouldn't have had to make. Being a parent was hard. Suddenly I wanted to take back everything I'd said about bike riding and risk taking. I wanted to tell the mother to go home and wrap her kid in protective layers so he'd always be safe. She was right to come and warn me of the peril of my words. What if suddenly every parent in the room encouraged his or her kid to go bike riding? It would be a disaster.

"I thought the doctor was right, that I was an unfit mother. I mean, who in their right mind lets a blind kid ride a bike? But I feel better now after what you said. He has a disability but he has to be a kid." She sniffled.

I wasn't sure what to say. In my heart I knew I believed in what I'd said, but I didn't want the woman to feel the need to get her son back on his bike. This wasn't really about bike riding. It was about living life to the fullest extent possible even with a disability. And not letting others define your life for you.

"It's a hard balance," I said. "Maybe he'll enjoy chess while his

arm mends. Or riding the roller coasters. I know I did. And then you can think about the next step."

"Yes," said the woman. She was smiling now, her voice sunny and warm. "I just remembered something. When the doctor asked my son how he'd broken his arm, he said, 'Riding my bike.' And he sounded so proud of himself."

As I packed to go home, I wondered whether the boy would choose to ride his bike again or whether the broken arm would be enough of a badge of honor for him. Whatever he chose he was the stronger for knowing that his mom had believed in him enough to let him try.

Robot

Life on Cloud Nine

After my first presentation public speaking became easier for me. Not all at once but, little by little, I felt more comfortable getting up on the podium and standing in front of a crowd. Over the next several months, I received countless invitations to different conferences and I went whenever I could. I squeezed it all in between going to school and painting and art workshops. The workshops were my favorites as I loved the hands-on aspect, the sharing of my love for art, but I was aware of the wider audiences I could reach with lectures and keynote speeches, of the real help and advice I could offer to people with disabilities. And it was interesting because when I started giving lectures it was the first time I really felt comfortable in my own skin. I found a place for myself in the disabled community, one that I wasn't aware I'd been looking for. Or needed. There my blindness and my epilepsy did not make me stand out from the crowd. I felt accepted. It was like being at Mable Peabody's all over again.

That year I had seven local art shows and sold several paintings. It was exciting, and I made enough money to keep myself in oils and canvas for a little while longer. A nonprofit organization submitted my name for the Presidential Volunteer Service Award. It turned out I had logged more than eight hundred hours

of volunteer work between all my public speaking and work-shops, and so I qualified for a gold-level award. I was thrilled. And amazed. I had no idea I'd spent so much time interacting with people. I guess I still wasn't getting much sleep.

Almost immediately this became my life. All-consuming, it filled my days, weeks, and months around the clock. It was what I did and who I was all rolled into one. Everything revolved around my painting. This need to paint flowed through my veins as blood and through my lungs as air. It was the way I had survived, the way I lived, and the way I would make my living. It was central to every aspect of my life. I wasn't someone who woke up as one person, went off to the studio, became an artist and painted for a while, and then went home for dinner while leaving the art-ist persona among the paint pots. Not me. I lived, breathed, and slept painting. And now, by extension, I lived, breathed, and slept workshops, volunteer hours, and art shows. It was all connected; all part of the same cycle. I couldn't stop. It made me alive in every sense of the word.

Almost without realizing it, I had attained my goal of inde-pendence. The impossible goal I had fled in sheer terror, then embraced because its alternative—dependence—was too awful to contemplate. I had done it. I was an independent adult. And yet I wasn't. I was very cheerfully codependent.

Mixed up in the center of my world was Jacqi. We went to galleries together and she explained the art to me still, tracing pictures on my hand. We rode her motorbike together and lis-tened to music—jazz, country, classical, whatever was playing. It was all great quality—the university had an amazing music pro-gram. She worked incredibly hard at art workshops, helping to set up the paints, the paper, the kids, so I could be free to focus on the content of the workshops. She drove me to conferences and volunteered at disability events. She took photographs and I

painted, and we shared our art, our hopes, and our dreams. And we talked about getting married. Having kids even. It was a place I had never thought I would get to. For me marriage was about stability. I thought about my parents; they had been married for years and had supported each other emotionally and financially through good times and bad. My whole life had been unstable. I'd spent my childhood in and out of the hospital. My body had let me down and epilepsy had laid me low both literally and figuratively. I'd woken up in the emergency room more times than I'd like to remember. Probably more times than I could remember, given what the epilepsy drugs did to my memory sometimes. I had also been told I didn't have long to live. My life had not had the kind of stability that made me dream of marriage, of spending my future with someone and growing old together, sitting on a porch in the country waiting for that final sunset.

Then I'd gone blind and I'd stepped out of my unstable world into a universe where nothing mattered anymore, where marriage was as likely or unlikely as flying solo around the world. It just wasn't something I thought about. Then I'd started painting, and I'd met Jacqi. Life became Technicolored. It was true that I still had seizures, and it was true that I had woken up in the Emergency Room holding Jacqi's hand, but it seemed different. It seemed manageable. Life on cloud nine was the most stable it had ever been for me.

As we both came from an Irish lineage and both had a good sense of humor, Jacqi and I thought it would be fitting for us to marry on St. Patrick's Day. So on March 17, 2007, we were married in Las Vegas with all our family and friends present. We had thought about a wedding in Texas but decided instead, as many of our relatives would have to fly in from somewhere, to make a vacation out of it. So for a week I was able to meet and hang out with

Jacqi's family and get to spend some time with my own. In Vegas of all places.

Everyone told me how beautiful Jacqi looked but I knew that for myself. I could see her radiance in my mind's eye, through all my senses, and could hear the smile in her voice. The lilting laugh that had first caught my attention rang by my side throughout the day. Technicolor was back.

From the traditional wedding with tuxedos and flouncy gowns, we converged on the reception at our hotel. Jacqi and I hadn't been able to resist—we'd gone with a Star Trek theme and we met our guests on the *Starship Enterprise* while a fake star field shone overhead. For a moment I remembered my images of Saturn—carefully saved forever in my mind—then turned my attention to the delicious buffet. Although my mom was terrified of the Klingons, the evening was one of the greatest of my life. It felt so good to be silly, to be surrounded by people who meant so much to me, who had stood by me during my worst moments, and, of course, to be married now to Jacqi. It was more than I could ever have imagined.

Later that night when our guests had all returned to planet Earth, and Jacqi and I were alone ordering a late night pizza, I somehow managed to lock myself out of our room. Without my cane. I laughed at my foolishness and knocked on the door, pizza in hand. No response. I knocked again, louder this time, remembering that a very long hallway led from the door into our room and that, with music playing, Jacqi wouldn't hear me. Still there was no answer.

All of a sudden I was physically ungrounded, floundering along the hotel corridor and down to reception in search of keys, trailing walls with my fingertips, and feeling unsuspecting strangers. I must have looked quite strange, the blind bridegroom

holding pizza aloft, apologizing, and stumbling through unknown territory. But mentally I was fine. I knew this was just a temporary setback, one that was even funny, and soon I'd be reunited with my key, my cane, and my life. There was light at the end of this tunnel. It was reassuring to know I had a place in the world.

Perceptions

A Gallery Full of Eyes

Despite my long hours of constant practice, I still painted very slowly, so slowly in fact that I couldn't sell any of my paintings before my show in Lake Charles, Louisiana. Each piece had at least one person who wanted to buy it before the show, but I had to wait. Selling even one painting would have meant not enough artwork at the show, and I didn't want to do that. I'd been preparing for this show for a year. Usually it took me from two to four weeks to finish a painting, but here I was working with thirteen pieces making up a series. It reminded me of a novel in which one theme could be looked at from many perspectives, whereas individual paintings were much more like short stories, making a statement that began and ended in a single work. That was the way I was used to working. With a series, however, the paintings had to have the visual strength and depth to hang alone but they also had to complement each other. It was a much more complex experience to hold the other paintings in my head while working on a different one. I felt like I'd taken up acrobatics or juggling on a tightrope, and I hoped it would all work out.

This series started as images of eyes in my mind. Eyes looking out of slivers of faces, just eyes and nose and a hint of top lip, or eyes and a streak of hair. I knew when this happened that

I would have to paint the images out of my mind onto paper or canvas and give them a place in the world. Just to free myself of them as I had when I first went blind and the constant flickering images drove me crazy. But there was something different about these eyes. They caught my attention and made me think. They were telling me something. They were not randomly generated at the back of my mind while I was pondering other things. These were rational images, carefully constructed images painted in my mind. But why? I wondered if the eyes were a symbol of my blindness and whether this was part of my acceptance of myself as blind, as having a place now in the community of the blind as well as in the sighted world. Maybe. But it didn't seem quite right. For one thing the images didn't go away. For several days the eyes hovered at the edge of everything I was doing, waiting for me to stop for a second and acknowledge them. Each time I saw them, my mind started whirring. When I looked at them, they looked back. They made a statement.

Finally one night I understood. I would transfer them from my mind onto canvas one by one, but that would not be the end of them, it would be a beginning. I would paint them as a series, my first, and hang them in my next art show, where they would look out at everyone who came to look at them. It would be a show full of eyes staring from the walls into the eyes of gallery goers. I would name the series *Perceptions.*

This show at Gallery on the Lake in Lake Charles, Louisiana, was a big show for me as it was where I first had a real statement for my art. After my first few shows, I had stopped hiding myself away at the openings and now presented my work along with my biography. My blindness was not a secret. It was who I was, part and parcel of my art. Now, I was using my vision loss to challenge and engage artgoers. With *Perceptions* I was specifically asking people to think about our perception of what it is to see and to

know, to confront misperceptions about blindness, to understand the negative connotations of the word "blind." I wanted them to think about what vision really is, about how we see. The show was the culmination of a lot of my thinking from the last couple of years, and I was excited to be able to challenge people's understanding of perception, of blindness, by presenting myself as living proof that everything we have been taught is wrong.

There were thirteen paintings in the show, all depicting a different pair of eyes. When you walked into the gallery there was a really strong sense of being watched, of being questioned, like in those old houses where the eyes in the paintings follow you around the room. But here there were only eyes. When people looked at them, the eyes looked back and said, "Really? Are you sure?" It wasn't aggressive but it was engaging, as if you'd gone out for a casual burger and ended up at an intellectual dinner party. It wasn't what you'd expected but you were happy to rise to the occasion and use your brain. I had written an artist's statement for the show and it came from the depths of my being, a plea for people to look and understand and then reconsider. In the dictionary and thesaurus I had found countless disturbing synonyms for "blindness" that had shocked and insulted me, then numbed me into a feeling of helplessness. People used them all the time without thinking. It was part of the "if you're blind you must be helpless" mentality. I decided this was my opportunity to do something about it. I made a list of the words and put it in my statement. It was striking. Synonyms for blindness: "Unknowing, unquestioning, careless, heedless, ignorant, imperceptive, inattentive, inconsiderate, indiscriminate, injudicious, insensitive, neglectful, oblivious, thoughtless, unaware, unconscious, undiscerning, unmindful, unobservant, unreasoning."

I read somewhere that if you want people to be honest you should hang up a picture of an eye—in the office kitchen or

supply room that works on the honor system. It gives a feeling of someone watching over you, even if it's just your own moral conscience. I wondered what would be the effect of thirteen pairs of eyes staring out from the walls of an art gallery. Certainly no self-deception could exist. Maybe it would help people to look deep within and change their preconceptions.

My series of paintings attempted to answer questions about perception not through words but in paint and canvas. I was intrigued by the masked hero or heroine in television shows and movies hiding their identity by simply donning a mask. It seemed incredible. No mask, you're Bruce Wayne. Mask, you're Batman. But then I had put on a pair of dark glasses and people had not known who I had become. My paintings focused on eyes, on the very area that a mask would cover, thereby "unmasking" the subject. Once unmasked, there was no place for the person to hide.

When people asked me about perception at the opening of my show, I told them about my mother. How when I looked at her I didn't have the perception of just one thing. Instead, I perceived the love that she had for me, the love that I had for her, all of the birthdays and holidays that we shared together, the arguments, the apologies, and the thousand other experiences and memories. While all these single events had an existence of their own, together they created the ever-changing form of my mother. In painting this series I had tried to recognize this concept by separating each color so they stood alone in the paintings but came together to form one image.

At the gallery opening I was pleased to speak about my art, about being a non-visual visual artist. People still had questions about how I painted, were still impressed that I could pick up a paintbrush as a blind person and paint, and I felt connections start up on some level with each person with whom I spoke. But I also noticed a shift. I was being defined less as a blind artist, and my

paintings were beginning to speak for themselves. They were getting people to move beyond the initial surprise of a blind person painting to a place where they could open up to questions about art, life, about what it means to see. That was especially gratifying to me. The more I painted the more I was convinced that the difference between a blind painter and a sighted one was very slight. Art comes from our minds and our hearts and is in no way limited by our visual field. Standing with Jacqi, listening to people talk around us, I was struck that we can fully understand someone only when our perception matches theirs. It was frustrating because it rarely happened; then again, it was a miracle that it ever happened at all. I squeezed Jacqi's hand and she squeezed back. I didn't need to say anything. This was one of those moments.

Jack's Friends

Extreme Joy

When Jacqi and I married, we thought we would wait two or three years before starting a family. It seemed like the sensible thing to do. In reality, three months into our marriage we discovered that she was pregnant and we decided it was perfect timing. For me fatherhood conjured up two emotions: joy and fear. Whenever I thought about Jacqi and me having a baby, both pride and excitement swept through me in a whirlwind of color. The feeling would lift me up and carry me through my day. I painted in bright colors. Life was a celebration. The thought of having a baby as a generalization was thrilling to me. The specifics were another story. They terrified me—and opened me up to my old doubts and fears. I knew that everyone had fears about parenthood, about this new phase in their lives, the financial worries that go along with it, fears of growing up and being responsible. I had those fears, too. But suddenly in my mind I was defined only by my disabilities again, by my blindness and my epilepsy. I worried that my health would get in the way of me being a good father.

I imagined a group of typical American dads taking their kids to the park or playing in the backyard, throwing and catching baseballs as the day turned into evening. I pictured one of the kids

throwing a ball to his dad, who caught it brilliantly in his base-
ball mitt, lifted one child onto his shoulders, took another's hand,
and skillfully walked them home through the dusk. I saw myself
on the sidelines with my cane, my child scrabbling around in the
leaves, because his dad couldn't throw and catch a ball because
he was blind. Such images broke my heart. In my rational mind
I knew that fatherhood was not defined by the ability to throw
and catch a baseball, but this was the image my irrational mind
conjured up time and time again.

There were other thoughts too about how kids dealt with par-
ents with disabilities. Would I be an embarrassment? The father
locked away in the basement when friends came over? Or kept
in my studio? I imagined the whispers and stares, the pointed
fingers and snickers of laughter. As I knew from my experiences
with the art workshops, kids were painfully honest.

On a practical level I wondered when I would have time to
paint with a new baby in the house, and the thought of not paint-
ing left me gasping for breath. But then I would leave the specifics
behind and return to generalities and let that wash of color soak
me and relax me and fill me with hope.

Since I lost my sight I had seen emotions as color. Probably
I did this to a certain extent in the sighted world too, but there I
learned to conform along with everyone else. I learned to keep the
colors in the background and focus on what I could see. When I
went blind my mind's eye provided color, and the more I painted
the deeper the connection became between touch and color,
between texture and color. When I first met Jacqi, she literally
colored my world as new emotions sprang up inside me, and just
holding her hand set off a riot of emotions and their correspond-
ing colors. During her pregnancy, whenever I was around her, I
felt as though new colors had been added to the color spectrum.
It was an especially bright time for me.

As to be expected, Jacqi's stomach went through an extraordinary transformation. Resting my hands on the smooth mound of her belly became restorative to me, an act of faith. By gentle touch I could see the baby developing inside her as clearly as any ultrasound and with much more detail, color, and movement. I saw our baby in vibrant oils, head tucked in between perfect hands and feet. Sometimes the baby turned toward my touch and Jacqi's stomach rippled under the assault of a tiny elbow. We laughed together then and my fears slipped away.

I threw myself into everything I did, riding high on the sunny emotions, keeping the fears at bay. I continued with more talks, conferences, and workshops for the Easter Seals, the National Federation of the Blind, the American Foundation for the Blind, the Epilepsy Foundation, the DARS organization, the VSA, an international organization for arts and disability, and countless museums and galleries. I traveled further afield to Indiana, California, and Florida, where I made keynote speeches and gave talks and held workshops at universities. I even went to The Netherlands and met the prime minister. Locally, I started to go into Texas schools on a regular basis, invited there to give workshops and talk to the kids. I loved it. It was interesting that while I had found a place for myself in the disabled community, more than 90 percent of my volunteer work was for the able-bodied. My artwork was viewed as a bridge between the two communities, as a tangible way for the sighted to begin to comprehend disability. It was exactly what I had hoped for, and I happily gave long hours to this cause.

And I still went to school. Classes took longer for me, as I was using various methods to read the textbooks, but I loved the work, enjoyed using my brain and the opportunity to keep learning. Education was hugely important to me, and I was determined to get through my workload, get rid of the Incompletes on

my transcript, and graduate. I didn't want to tell my child that I hadn't finished college.

When our son, Jack, was born on March 9, almost a year to the day after our marriage, all my fears went away. It was as if they had never existed. All I could feel was extreme joy, as if there wasn't room for any other emotion in my body. I was laughing, I was crying. My world had never been more colorful. The doctor laid Jack on Jacqi's stomach moments after he was born, and I felt his tiny face. I saw his expression as he took his first breaths, and in those seconds I learned more about the true nature of color than in any of the dozens of books I had read about color theory. I saw his little mouth open and close in surprise at the world, his face twisting in the light, tearing at my heart. I had never seen so much. In that moment I knew that my son wouldn't mind if I couldn't throw a good curveball, wouldn't mind that I couldn't see in the conventional sense of the word. He would love me for who I was, my whole imperfect package, because I loved him the first time I saw him, and I would lay down my life for him.

My world exploded with emotive color after Jack was born, with each new milestone we proudly charted: the first burp-turned-chuckle, the first squeeze of chubby fingers in my own. My mind's eye lit up with bright flashes of joy.

A few months after Jack's birth, I graduated. It had been a seven-year journey for me from that first English class in 2001 that I took when I was still sighted. That was a long time ago in terms of time, but it seemed like universes ago if I thought about everything I had undertaken since. I graduated magna cum laude and couldn't have been more proud of myself. We had a big celebration that night, Jacqi, my parents, our friends, and little Jack.

In some ways I was sad that one part of my life was over, but on a practical level it gave me more time for my painting and my volunteer work. And for Jack. I was learning that babies like

to take up every second of time they can—and that I was will-ing to give all the time to him that I possibly could. Sometimes he would wake in the night and I'd carry him downstairs, where he'd be my nocturnal partner, dozing on my shoulder in the dark-ness while music played and Jacqi grabbed some much-deserved and much-needed sleep upstairs. I loved the weight of his head against mine, his complete trust in me, a small finger linked in my hand. I remembered the nights when I first went blind, and I stayed up at night with a constant stream of panicked thoughts racing through my head. It wasn't like that now. My thoughts were much more mellow. The soft hues of peace. Of calm. Of hope that babies bring.

Echo

CHAPTER THIRTY-TWO
Finding Echo

In December I received a phone call from Sandy with the Guide Dogs of Texas. They wanted to come out and see me and conduct another interview. I was pleased. It sounded like progress. Maybe after this interview the next call would be to tell me they had a dog for me. With Jack's birth I had become aware again of my limitations with my cane. I couldn't push a stroller easily, and it was difficult for me to navigate outside with the needs of a baby in my head and a cane in one hand. And I knew that was just the beginning. I had been starting to hope that the guide dog situation would soon be resolved, and now I hoped that this second interview would go well.

To our delight it went even better than expected. The next week when Sandy and Mary arrived at the house they weren't alone. They had a black Lab with them. "John," said Sandy, "meet Echo. We think she's a match for you." I felt my heart leap inside my rib cage. It was such a surprise and so exciting to have my very own guide dog if everything worked out. I leaned over to feel her face, the smooth hair and nose, and could see her calm, intelligent demeanor. I knew she was looking at me, not staring, but assessing me, questioning if I needed anything. I would learn that this quiet study is a trait that all guide dogs have even if there is chaos

breaking out all around them. They will sit and read their owner's face. I was entranced. Echo came from a long line of guide dogs from a New York breeding program that had bred guide dogs for years. She had incredible guide dog pedigree. For me, I trusted her as soon as I felt her face.

After this first meeting I didn't see Echo again for two months. I felt quite bereft. She was very much on my mind though as I launched myself into a series of dog paintings. I had always loved dogs, still had my beloved Ann with me, and these paintings helped me to form my own bond with Echo even though we weren't together. When I wasn't painting dogs, I dreamed about them, with dogs of all colors populating my night visions. I hadn't realized I wanted a guide dog so much. In some ways it was like my experience with Jack. The joy and the worry gave way to pure joy when Jack was born. My anxiety about losing my cane had disappeared when I sensed Echo looking at my face. Now I felt giddy with excitement, knowing that come what may, she would lead me through. I couldn't wait to get started.

There are as many misconceptions about guide dogs and their relationship with their owners as there are about perception and the ways in which we see. I was put straight about everything during my weeks at guide dog school in San Antonio. The biggest mistake people make is thinking that the guide dog leads the owner. Probably the term "guide dog" is to blame for that. But in reality the owner tells the guide dog where to go, what to do. Even at a stoplight it is the owner who decides when to cross the street, not the dog. The guide dog is trained, however, to practice intelligent disobedience. This means that if the owner steps into the street—or another place—at a dangerous time, the guide dog will stop the action by pulling the owner out of harm's way. This is the only time that the guide dog will take the lead instead of following the owner's instructions.

Butterflies flitted in my stomach while I was waiting to see Echo again. I could have been a teenager on a first date. I wanted to feel that solid, calm nose again, have her dark eyes gaze into my face. I didn't have to wait long before she was brought out by her trainer and I was down on my knees making a fuss over her. Since I had last seen her she had been training hard with five other dogs, sleeping in a kennel at night, but now she would sleep with me. My room at the school was set up with a kiddie gate and a dog bed, so Echo could go in and out. And, more important, so we could get to know each other and bond one-on-one.

The school was out in San Antonio, a good five-hour drive from Denton, from Jacqi and Jack. I tried not to think about them too much, but they were like limbs missing from my body. Their absence gaped at me and tugged at my insides. I needed them at every turn. Part of me begged to turn on my heel and leave this unfamiliar place behind, but I knew I couldn't. I had wanted independence for so long. And there was Echo. To give up and leave her would have felt like a betrayal.

Guide dog training at Guide Dogs of Texas began with the careful selection of puppies from trusted breeders, and then the pups were raised and socialized by volunteer Puppy Raisers who provided them with near-constant companionship and daily obedience lessons. The puppies would learn basic commands: sit, down, shake, and move on to down and stay, carry, bring, and take. They learned to locate bathrooms, water fountains, and garbage cans. At around twelve months of age, the dogs went to the school to start formal training with a Mobility Instructor. It was an intensive process, and I was aware that only a few dogs were matched each year. I felt incredibly lucky. I would handle the couple of weeks away from home.

In the beginning the training reminded me of those early, frustrating days with Alexa when everything was new. One of the

people I'd spoken to who had transitioned from cane to guide dog had told me it was a little like learning to drive on the other side of the road. That had sounded pretty straightforward, just a reversal of habits. For me it was more complex, partly because of the emotional shifts I experienced. All those nocturnal hours of practice, the scrapes and bruises and rides on roller coasters, meant that I was extremely good with a cane. Now I was back to square one. I didn't like that feeling of being a beginner again, of edging forward instead of striding with confidence. It put me back in a negative mind frame. Without my cane I felt ungrounded, as if I might fly off the world's surface at any moment into the atmosphere. I held onto Echo's leash for dear life. It seemed strange to have a dog by my side, a living presence to which I could communicate my needs. It felt like going from living alone to living with my parents and having to detail my plans and movements every time I left the house. This was teamwork and it was new to me. But at the end of each training walk, I had Echo's silky ears and solid face to pet, and her intense gaze on my face. I had a guardian angel.

By degrees I began to master the new training, this new way of getting around. The gratitude and happiness I felt around Echo started to translate into a working relationship. The free-floating experience disappeared, and I was able to lightly hold the leash and command her with a word, a touch. She was amazing. She obeyed every command instantly, but more than that, she seemed to anticipate my very needs. I couldn't wait to take her home and finish my training with her there.

It was a simple walk downtown that made me realize just how Echo was about to change my life. We were getting used to dealing with crowds together and were making our way through a throng of people to a coffee shop. That was the first eye-opener. With my cane I would have bumped into or been bumped into several times by now, but Echo found the best way to go and the crowd of people

surged around her. At the coffee shop I told Echo to move forward and find a seat, and without a moment's hesitation she led me across the room to an empty table in the back. With just a cane I would have entered the restaurant, listened to the noise level in the room, and headed in the direction of a quiet area, using my cane to look for obstacles and find a chair. I would have sat down hoping the table was empty and not occupied by a very quiet person. If I needed to find the bathroom, I would have asked the waiter or waitress to physically guide me there, then to guide me back. Usually they would wait by the door for me, which always made me feel that I was stopping them from working, and so I would feel the need to hurry. Even my local restaurants could be difficult to navigate as people were always moving around or standing in different locations, or furniture would be randomly moved, so a simple trip to the bathroom could be perilous. I would constantly make mental maps, filling them with as much detail as possible and updating them on the go. It was manageable but exhausting and often frustrating. Sitting in the restaurant with Echo, I understood that I could say, "Bathroom," and she would take me straight there, avoiding people and furniture, wait for me, and bring me back to my seat. It was liberating. She was my personal GPS system. I thought how much easier it would be to take plane trips and taxi rides, to find hotels and museums in unknown cities. She would open up another new world to me. I was struck again by how I had once viewed the world of the blind as a place where I would never experience anything new, where I would just be trying to accomplish to the best of my ability everything I'd done in the sighted world. And I had viewed it as a place where I would, for the most part, be failing. Again I realized I was wrong.

In my room at the school I stayed up late, painting. I had explained that painting was my lifeline, my means of support and way of expressing myself in the world, and was given

permission to bring my materials. I worked on a painting of Riley, a dog who greeted Echo and me on our training walks. My music played softly, a semblance of my old life at home. But now I had Echo at my feet, lying at the foot of my easel. I moved her doggie bed over to be closer to me, but she preferred to lie near me on the floor. Sometimes I knew she was looking at me, waiting for an order, but after a while she would put her head down and snooze. She seemed to understand that I was fine in my world of paints. I didn't need anything from her or anyone else at that moment. Maybe she read my sense of calm. Once in a while, between colors or just when I needed to stretch, I would wipe off my hands and bend down to pet her. Then her head would lift and I would hear the thump of her tail in the darkness. We were a team.

Sometimes it's important to step away from one's life to see it properly, and that was what I was able to do from my room in San Antonio. For the last couple of years I had been so caught up in the process of life that I hadn't really had a chance to think. But from here in the small hours of the night, I thought about Jacqi and Jack asleep in our house three hundred miles away, Jack curled up on my side of the bed now that I wasn't there. He would be deeply asleep, his arms thrown back against the pillow, Jacqi's protective hand draped across his chest. I saw the covers rise and fall with their breathing. At the foot of the bed Ann twitched in her sleep, one paw shaking, her ears alert. On the distant highway a truck rumbled by but did not touch their sleep. Downstairs my studio stood empty, paints and brushes by the sink, paintings on the wall, all defined in bright colors even though it was nighttime and the lights were out. I saw now the house from above, as if I was flying overhead, and I was struck by how small it seemed in the vast scheme of things. But to me it was everything. A life I had worked toward one brushstroke

at a time. I saw the house now as if it were a painting I had created with raised fabric lines and vibrant oils, transferred from an image in my mind onto canvas and there it lived, an expression of myself, my thoughts, my vision. A house surrounded by other houses, other lives, a patchwork of fields and roads. In my mind I called the painting *Home.*

Smokestack Lightning

What a Colorful World

I was sitting in a coffee shop listening to music, with Echo at my feet, when I felt a light touch on my shoulder. That wasn't unusual. In the same way that a white stick used to make me invisible, Echo invited company, and I was often approached by strangers now asking if they could pet her. I always said yes, unless we were crossing streets, which made for slow going around town.

"I'm so sorry that you can't see what a beautiful day it is," said a woman's voice. I was so surprised that she didn't want to talk about Echo that I was speechless. Then she was gone. Like a char acter in a fairy tale, a witch or a sorcerer, who delivers bad tidings or a prophetic curse and moves on. Her words jolted through me again. For a second I felt that old sensation of fear uncoil itself in the pit of my stomach, ready to slither back into my life. When I had first gone blind, a couple of people had stopped me on the street wanting to bless me or pray for me, telling me that blindness was a curse from God, a punishment for my sins. That had been during my angry period, and I had fumed inwardly and waved my stick at them. It had not surprised me though. It seemed in keeping with my miserable existence back then.

This woman did surprise and unnerve me, as if she had slipped in through a back door that I didn't know existed. I had

been enjoying my time in the coffee shop, sipping an herbal tea, taking in the warm cinnamon scent of it and listening to great music. My mind was full of colors inspired by the bass guitar solo, orange, yellow, red like a sunset, melding with the woody aroma of the tea and perfumed clouds of rose and violet from a woman sitting next to me. Even the rough wood grain in the table center had a different hue than the worn edges. I was remembering a workshop we had put on the day before, the kids' enthusiasm for painting music, for the exuberant splatters of paint that it inspired, and thinking about a series of paintings I was working on about the senses that portrayed a visual response to sound or to taste. How would I paint the tea I was drinking? Or wine? And then I was thinking about how color for an artist must be like the different flavors a wine expert can taste in wine, and not only that, but can compare to a wine that she drank five years earlier but whose flavors are still imprinted somewhere in her brain.

Then the witch from the fairy tale showed up and knocked me from my happy place. She made me vulnerable again to self-doubt. Just when I was thinking about how great my life had become, there she was to say, "How good can it be? You're blind." The terrible thing was that the woman wasn't an evil villain. She was trying to be nice, attempting to empathize with me, but she had missed the point. She was wrong. Being blind didn't mean living in a world of darkness. I took another sip of tea, a calming sip. It would take more than one misplaced comment to set me back where I once was. Maybe a year ago I would have allowed this to really bother me, but not now. I was beyond that. I'd found my bridge and crossed over. Comments like that were a part of other people's blindness. The music began to seep back into my mind, the oranges, yellows, and reds, the bass guitar turned into a full orchestra in my imagination, welcoming me back into a

world of possibility. I knew that my world now was much more colorful than the one I inhabited before I lost my sight. If other people thought I lived in darkness, they were wrong. I lived in a world of purple cows.

Romeo y Julita

Flying

Sitting in the cockpit of a two-seater trainer plane, surrounded by gauges, buttons, and levers, I was intensely aware that an aircraft is a precise instrument of control, but with the wind buffeting the pilot and me on either side I never felt in charge. Out of nowhere rising thermals lifted the plane, pushing me deep into my seat, and then just as quickly they dropped me so that I strained against the harness buckled over my shoulders and across my chest. The plane slid from left to right as the wind shifted, and it seemed that at any given moment the plane could go anywhere—up, down, left, or right. There was no sense of ever having complete control over the plane, but instead it was a process of adapting from moment to moment to guide the plane forward. It felt a lot like painting, that notion of having some idea of where I wanted to go, and then working and reworking until I achieved my goal.

My flying lesson was the first step toward a new art project, and it was another huge step for me. Like painting, flying was something I had never done before losing my sight. Another new experience for me, further proof that being blind didn't have to close off doors of possibility. My plan was to paint the sky with streams of colored smoke, precisely placed to create a

huge abstract mural. I had been thinking about street murals, about how large one could go with a painting and the limitations imposed by galleries and even the walls of buildings. I had thought, almost laughingly, what a shame it was that we cannot paint the sky. Imagine that, a canvas that touches everyone and is only limited by natural laws. Once the idea had come to mind, I couldn't let it go. It filled my head for days, a beautiful vision of artwork high above the Earth. I pictured the majesty of the sky and all the sunrises, sunsets, and rainbows I'd ever seen. The multitudes of hues of clouds lit by lightning or made heavy with snow. Such images inspired a vision in my mind of people on the ground looking skyward at my colored smoke, experiencing the art as it unfolds, as it transforms.

I was excited by the prospect of this new artistic endeavor. In my mind's eye it was already a successful vision of beauty. But I knew there were practical issues to address: the placement of the smoke, the weight of the canisters, the colors of the smoke, and the type of light plane I could fly. There were questions to consider about artistic control and creative spontaneity and how much of each I would have. All details to be worked out. But first I would focus on flying.

For now I was in the early stages of planning, and this first flight was one of several that would qualify me to fly solo. In the seat next to me, the pilot guided me, explaining what to do and when, telling me the readings on the different instruments. I listened intently, absorbing information it seemed with every pore of my body. It was a lot to handle, a little like using a cane for the first time. I felt as if I was crossing a road again with Alexa, following her cues, feeling my way forward, taking the same leap of faith. The plan was to phase out my instructor and rely on a computer to speak the instrument readings for me. The technology was already there—a blind Australian had already flown halfway

around the world using this method. In some ways I felt that the flying would be the easy part—the planning of everything would be the challenge. But that was for the future. Right now I was enjoying the liberation of flying, of thinking about the sky as a canvas, glad that there were no limitations, just endless expanses of possibility.

Jacqueline Street Studio

Epilogue

Today I received a phone call from the Texas Governor's Office. Now that I am the official resident artist of Texas, they've set up a schedule of events and appearances for me. They'd like me to head to New Mexico in August for the Southwest Disability Conference. Apparently the people there had seen me painting a portrait of someone on a TV talk show, and they'd like me to do a live painting of a musician while he's playing the piano. I pictured it in my mind, me up on a stage in front of a crowd of people. At one time I'd have been terrified but now I'm excited. They want me to paint the sounds of the music so the deaf people in the audience can hear it. I loved the fact that the woman giving me the information was as excited by this concept as I was, that she didn't question what it meant, whether it was possible, whether someone could see music. She knew all about the reality and possibility of perception—she'd been dealing with me for the past couple of years. I laughed. I loved the fact that a blind artist could interpret music for a deaf audience.

"Who's the musician?" I asked.

"Henry Butler," she said.

I nodded. He'd be perfect. Already I knew that my painting would be a riot of color. Just before I hung up the phone, the woman added, "By the way, he's blind." That much I knew. He was

a brilliant pianist, and I liked the fact that she had not defined him by his lack of sight. I wondered if when speaking of me people added, "By the way, he's blind."

In the past few years, I had become so many different versions of myself and I thought of myself in many different ways: a husband, a father, a son, an artist, a graduate, a volunteer, a mediocre cook, a jazz aficionado, a dog lover. The list could go on. And just as when I looked at my mother I didn't have one way to define her, I had an overall perception of her as well as an awareness of her individual traits, so too I had that feeling about myself. Among my physical attributes I would list my hair color, my height, and the fact that I was blind. My lack of sight was just one strand of who I was, one color in a portrait that made up the whole of me. I didn't want it to define me, just as I didn't want it to limit me. Being blind enabled me to find my artistic voice and my place in the world. It turned out that I needed to shout in the dark for a while before I could sing in the light. Well, I'm here now, and I'm singing at the top of my lungs in a world that couldn't be more colorful.

Acknowledgments

I want to thank Lindsey Tate, Katherine Latshaw, and Lara Asher for having the incredible vision to tell the story of a blind painter. I, and the millions like me, who have faced adversity and confronted an uncertain future, have found a champion in you three. I thank you with all of my heart.

I also want to thank my parents, Debbie and Gary Bramblitt. No matter how dark things may have gotten at times, you were always there to guide me, and I know that I was never truly alone.

—John

Thank you to James, Sophie, and Antonia for listening to early drafts in a mostly willing manner and for stepping onto notoriously thin ice to suggest changes. To Andrea Shallcross for enthusiastic support, practical advice, and good, plain gossip. To Sam Prangley for providing me with time to myself as deadlines drew near. To Frank Weimann and Katherine Latshaw for taking me on board. To Lara Asher for editorial excitement. And, of course, to John for being amazing to work with.

—Lindsey

About the Authors

John Bramblitt is an artist living in Denton, Texas. His art has been sold in more than twenty countries, and he has appeared internationally in print and on TV and radio, including the *New York Times, Psychology Today,* the *CBS Evening News with Katie Couric,* and ABC and BBC Radio. His work has received critical recognition, including three Presidential Service Awards for his innovative art workshops, and he's been the subject of the documentary short *Bramblitt,* which won the title of "Most Inspirational Video of 2008" from YouTube, among other awards.

John has never had to ask for an art show—he has fielded hundreds of requests for them and has held more than thirty shows in just the last few years. On average, John and his work are profiled in the press once every couple of weeks—on the local and state level but also in the national and foreign press—he's incredibly popular overseas.

While art was always a part of John's life, it was not until he lost his sight in 2001, due to complications from epilepsy, that he began to paint, and it was then that he says, "Art reshaped my life." John's paintings are intensely personal and are mostly taken from real people and events in his life. John's workshops are unique in the art world in that they not only span the gap between beginning

and professional artists, but also include adaptive techniques for people with disabilities.

In addition to his painting and art workshops, John is in talks to paint prominent NFL players for charity. He is also working on a book about haptic visualization (seeing through touch) and a book that instructs those with impairments—temporary or permanent—on how they can become artists. He also would like to author children's books based on his artwork.

Lindsey Tate is a writer living in New York City. Her most recent work includes *Mind Reader: Unlocking the Power of Your Mind to Get What You Want* by world-renowned mentalist Lior Suchard. She writes for magazines and online websites on subjects as diverse as Olympic snowboarding, World Cup soccer, Vermont country inns, and the pitfalls of parenting. She has a degree in French and Russian Literature, History, and Art from Cambridge University.